PEGASUS
Library

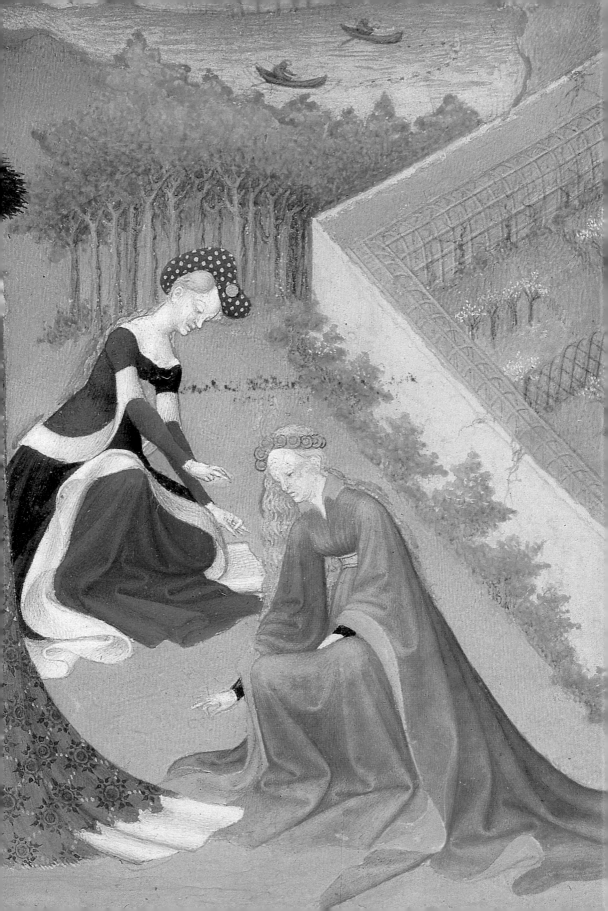

Lillian Schacherl

Très Riches Heures

Behind the Gothic Masterpiece

Prestel

Munich · New York

Front cover: The month of *April* (detail), see p. 52
Spine: The month of *May* (detail), see p. 57
Frontispiece: The month of *April* (detail), see p. 52

© 1997 by Prestel-Verlag, Munich · New York

Library of Congress Cataloging-in-Publication Data is available.

Translated from the German by Fiona Elliott
Manuscript edited by Kirk Marlow

Prestel-Verlag
Mandlstrasse 26 · 80802 Munich · Germany
Tel. (+ 049 89) 38 17 09 0; Fax (+ 049 89) 38 17 09 35
and 16 West 22nd Street, New York, NY 10010, USA
Tel. (212) 627 8199; Fax (212) 627 9866

Prestel books are available worldwide.
Please contact your nearest bookseller or write to either
of the above addresses for information concerning
your local distributor.

Designed by Karin Mayer
Lithography by ReproLine, Munich
Printed and bound by Passavia Druckerei GmbH Passau

Printed in Germany

ISBN 3-7913-1870-5 (English edition)
ISBN 3-7913-1851-9 (German edition)

Printed on acid-free paper

Time

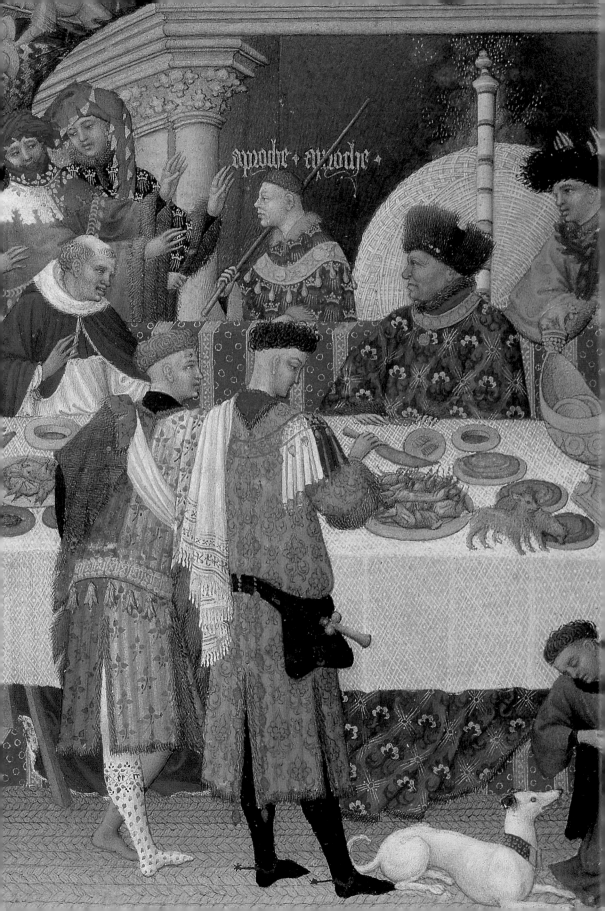

Time

Books of Hours — devotional books, many with exquisitely illuminated texts — were at their height at exactly the time when mechanical clockwork timepieces were also at their finest. Yet, when it comes to measuring time, an hourglass and sand or a clockwork timepiece with a raised weight and an escapement regulating the release of energy are as different as night and day. But as the years passed, the real regulator of time proved to be unrest, which "from this point onwards, [...] was the mechanical rhythm of the Western consciousness."[1] The new precision instruments were a scientific triumph. They not only displayed the time here on Earth and the movements of the heavenly bodies but also depicted worldly and non-worldly hierarchies. The most elaborate examples mark out time in the company of archangels or the twelve apostles, the seven Electors or allegories of virtue and vice. The clockfaces on church towers kept "individuals in step in their daily round"[2] and used numbers to keep worshippers accurately informed about times that previously they had only known as canonical hours: matins, lauds, prime, vespers and compline. Clockwork began its lap of victory in the early fourteenth century. Books of Hours flourished between 1400 and 1450. The *Très Riches Heures*, outstanding amongst its kind, was created in the early fifteenth century: timeless contemplation and modern precision — just one of the many contradictions that coloured the late Middle Ages.

It was a wild, colourful and passionate age — compassionate and callous, sensitive and savage — where sanctity and iniquity, self-indulgence and spirituality went hand in hand, where *joie de vivre* could so quickly turn to chagrin.

The Duke and his court at a banquet. (Detail from *January*, p. 42)

7

While in Paris eight hundred people a day were falling victim to the plague, others were asking the King to set up a *cour d'amour*, a literary circle devoted to courtly love to "pleasantly while away the hours." During the dynastic feud between the Armagnacs and the Burgundians, it was decreed that the Armagnacs should be excommunicated — so excommunications duly took place each Sunday to the sound of pealing bells. And when, during the same dispute, a certain Armagnac man was about to be beheaded, the condemned man forgave his executioner, requested a kiss from him and brought the crowd to bitter tears — which nevertheless did not stop the same crowd from buying the leader of a band of thieves for an exorbitant sum, in order to have him drawn and quartered as a fairground side-show. "Pious" Anna of Burgundy knelt at mass with the Celestines at night and cared for the sick in the Hôtel Dieu until she became infected and died, while "Wild" Anna of Burgundy indulged in extravagant festivities, tore through Paris on horseback and wilfully splashed muck on its citizens. The same knights who extolled the virtues of courtly love did not hesitate to take the object of their desire by force, a fact notably

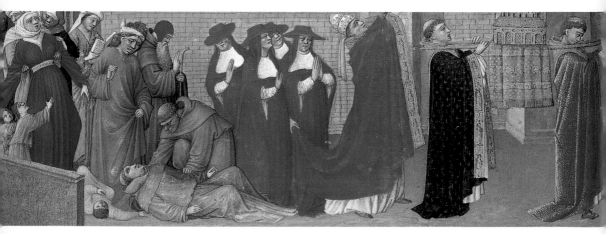

demonstrated by Edward III of England who otherwise set such store by cutting an exemplary figure. In the same breath as praising the beauty of this world, the poet Eustache Deschamps breaks into endless litanies: "Oh time of trial and tribulation, time of tears, of envy and of torment"[3]

SHAKESPEARE'S "GREAT DESIGNES"

In 590 Saint Gregory ordered a procession to entreat the heavens to end the plague in Rome. This scene was lent poignant relevance by the outbreaks of plague that swept Paris in the 14th century. (Detail)

Leaving aside the huge complexity of this period, we must restrict ourselves here to a very narrow slice of that time and society: the period in France roughly spanned by the lifetime of the Duc de Berry — 1340–1416 — who commissioned the *Très Riches Heures*. This was the time when France suffered the worst of the conflicts and catastrophes that were visited upon it in the late Middle Ages, tormenting and decimating its people, and destroying its unchallenged supremacy in Europe: religious schism, the Hundred Years War, the Black Death, and ultimately civil war.

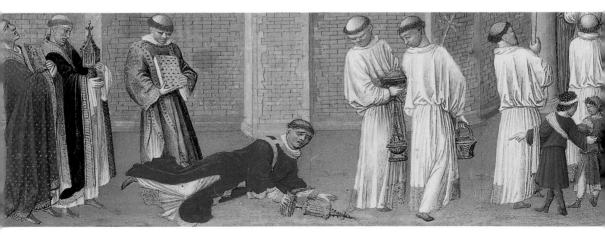

The dispute between King Philip IV (the Fair) and Pope Boniface VIII over politics and the Papacy ended in 1305 with the curia being exiled to Avignon. This gave France lasting influence over the papal court, which — even in exile — still wielded spiritual and fiscal power. But this temporary arrangement could not last, and so in 1378 a schism developed between the Pope in Rome and the Pope in Avignon including all their cardinals. Each regional lord now had to decide for himself between the two. The result was forty years of chaos, which did untold harm to religious faith at the time.

The Hundred Years War (1337–1453) was initially ignited by the question of the successor to the throne of France, after the last Capetian monarch, Charles IV, had died leaving only a daughter. In 1328, the house of Valois came to power with Philip VI. Ten years later, Edward III of England asserted his claim to the French throne as the grandson of the last Capetian and declared war on France over the sovereignty of Aquitaine, at that time an English feudal territory in France. With support from Flanders the English infantry spread conflict throughout France, whose regional lords were by no means solidly behind their own King. After English victories at Crécy in 1346 and Poitiers in 1356, and after truces and peace treaties, the war, nevertheless, continued for generations marked by battles and bargains, sieges and retreats, treaties signed and broken, royal alliances and renewed royal rivalries. It was not until 1453 that the English finally withdrew from the Continent after many defeats, and even then it took until 1475 for a peace treaty to be drawn up at Piquigny.

In the years between the battles of Crécy and Poitiers a different mortal enemy brought death to both sides: the plague. In January 1348 it was brought to France from Central Asia via North Africa. It broke out again in the following spring and was carried to England. It killed the wife of the French King Jean II (le Bon) and the daughter of the English King Edward III. In Paris, where it took exceptionally harsh hold, half of the

Sorcery, devils and the quagmire of hell: a wild fantasy depicting the fate that awaits all sinners. (Detail from *Hell*, p. 113)

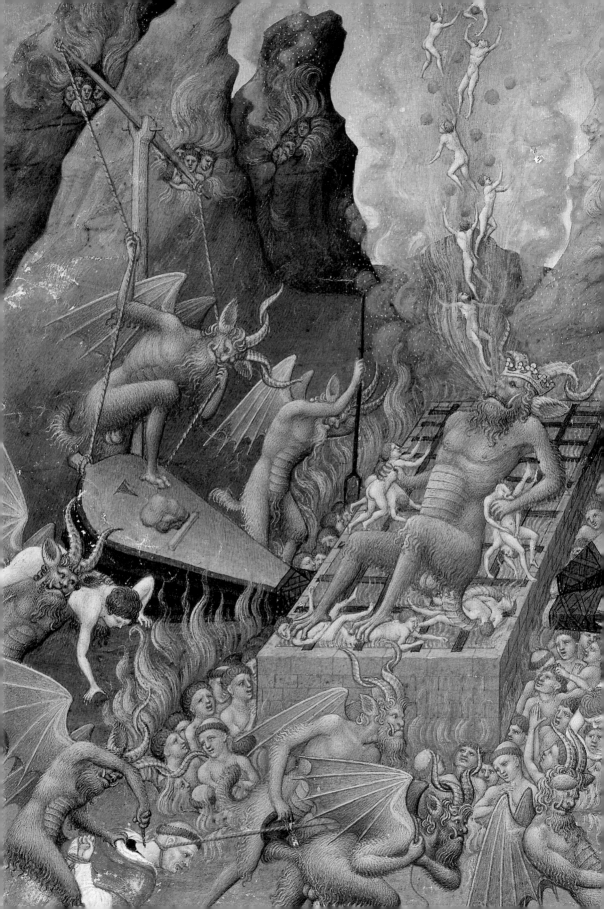

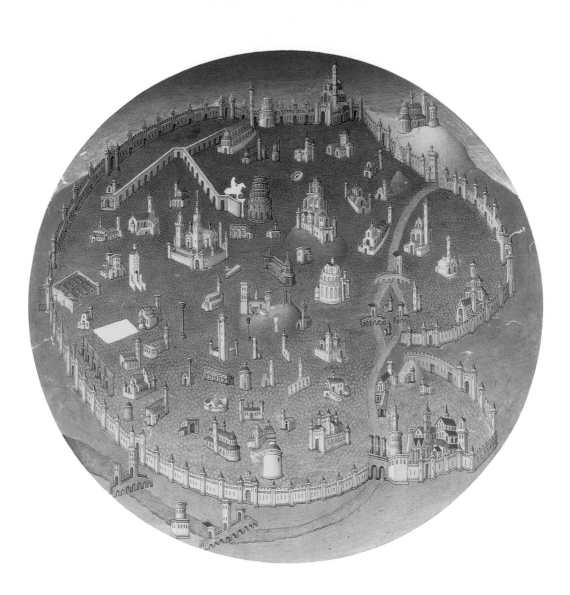

city's one hundred thousand inhabitants died in the short space
of two years. In many towns there was such a sense of despair
that bells no longer rang for the dead and the people were for-
bidden to wear the black of mourning. The Black Death re-
turned several times in the following decades — but where
sense, mercy and concord were needed it brought instead

cruelty, avarice, dissipation, the excesses of the flagellants and the persecution of the Jews, the latter who were held responsible for the epidemic. In addition to all of this, it made the poor poorer, because they had fewer defences in the first place. It utterly destroyed their livelihoods and raised their burden of taxes, while all the time the rich became richer because they inherited all the more from the deceased and could considerably increase their wealth.

The French throne was losing ground, weakened by the unpredictability of the mentally unstable Charles VI, and the extent of its decline became all too apparent in the struggles that were developing between the houses of Burgundy and Orléans, both determined to gain overall power in France. Their mutual hatred even went as far as murder: in 1407 the Burgundian Duc Jean (the Fearless) had Duc Louis d'Orléans assassinated in a street in Paris. Thanks to the intricate eloquence of Duc Jean's lawyer, Charles VI acquitted him of the murder. The unscrupulous duke proceeded to effectively curry favour with the people of Paris by opposing the levying of regional taxes. Civil war was inevitable. In 1410, under the command of Comte Bernhard d'Armagnac, an ally of the house of Orléans, an uprising of noblemen united against the Burgundians, both parties all the while shamelessly lobbying for support from England. In 1418, after years of combat, largely fought in Paris, the Armagnacs were defeated by the Burgundian reign of terror. In 1419, Jean (the Fearless), who tried to make pacts with both the English and the French, finally fell victim to his own double game: he was murdered by the Dauphin's supporters. Shakespeare's "great Designes" of power accurately expressed the truth of those times: "I had an Edward, till a Richard kill'd him" "I had a Richard too, and thou didst kill him."[4]

The brief outline of events above is essential, although the events may seem at first to have little to do with the Book of Hours of the Duc de Berry. Seen in this context, the *Très Riches Heures* are not so much likened to a paradisical garden flourishing somewhere in the blood-soaked fields of France, but are more like a glasshouse sheltering the rarest and most seductively beautiful hybrids — an image of the elite of the day, and a projection of how they would wish to have been seen. In their chosen mode of existence, devoted to the ideals of knightly behaviour, "where arrogance was equated with beauty,"[5] their lives were so stylised as to become pure ceremony.

Anything and everything became tactics and ritual — ownership, wealth, love, piety, virtue. Ownership was no longer something to be ashamed of, as it was in the early days of the knights when poverty counted amongst their puritanical virtues. Now ownership was a source of deep satisfaction, a way of achieving recognition and happiness. The forts which had previously served the dukes and counts as centres of power and demonstrations of strength were now transformed into comfortable centres of patronage. In the *Très Riches Heures* the Duc de Berry's châteaux, with tips like "glowing fireworks,"[6] are a constant reminder of this. The joy of ownership encouraged display, the power of ownership led to self-aggrandisement, and a hitherto unheard-of taste for extravagance swept through the French courts, above all in Burgundy. While opulent table decorations, grandiose wall-hangings and eccentric garb were favourite modes of conspicuous consumption, these were but a prelude to feasts and ceremonies, which sometimes took on such dizzying dimensions that one wonders whether the nobility were not simply patching over some deep-seated collective terror in the face of the catastrophes that darkened that time. There are descriptions of festivities at court where the table decorations consisted of manned ships and landscapes with

The wealth and beauty of the world outside the châteaux. (Detail from *The Temptation of Christ*, p. 114)

châteaux and windmills, where bands of musicians were accommodated in a baked pastry shell, where mechanical devices spat out live birds, and where whales, elephants, giants and dwarfs were on show: everything — tasteful and tasteless alike — created and arranged by a whole troupe of artists. But when the tide of festivities ebbed, some small sparkling stones seem to have been left washed up on the sand — namely the works of art that were doubtless also made for these occasions, since at the time there was still no clear division between display and art.

Love and warfare alike were regulated by rules of engagement and ended in either victory or defeat. When the French persistently lost battle after battle against the English and their manoeuvrable foot-soldiers, much of the blame was due to their knightly code of honour, for the French knights prided themselves on their thirty kilos of armour which cut such a dash on the tournament ground. At the defeat of Nikopolis in 1396, when the French troops were under the command of Jean (the Fearless), the Knights of the Cross had to cut off their fashionably long, pointed shoes before they could flee the enemy.

Meanwhile courtly love, a largely literary notion that played an important part in the life of the nobility, was stylised — particularly in France — into a complicated, almost platonic, yet highly erotic mental construct. In short, only unrequited love for another man's wife could be considered selfless love and, as such, the very essence of love. And all of this was taken into account in the tactics devised to win the lady, although, according to the rules, the ultimate victory would never be celebrated. Since this whole code of knightly conduct had been developed quite separately from the Church, the knights were proud of their own elitist status. If others followed the commandments of the Church when it came to love, the knights kept to the rules of their own exclusive, collusive game. At least in their game the lady was an equal player, if not the major

player, a fact which is interestingly reflected in the game of chess that was brought to Europe by the crusaders and which only acquired the Queen on its arrival here.[7]

The terms hypocritical, sanctimonious and deceitful by no means do justice to this stylised form of existence. The whole repertoire of refined living — from painfully exactly observed niceties of court etiquette to extravagant festivities to the sublimation and spiritualisation of sexuality and eroticism — derived from a value system of aesthetics and ethics that could comfortably hold its own alongside the value system of the Church, even if it was just as torn between ideal and reality as the latter.

The paintings by the Limbourg brothers in the *Très Riches Heures* show two worlds — the aristocratic and the religious — sometimes merging with apparent ease in a manner that sets these illustrations apart from those in other Books of Hours from that period. Depictions of properties owned by the Duc de Berry appear naturally and self-assuredly in the secular representations in the calendar sheets while, in the religious scenes, they are no more than a delicate line on the horizon. Though perfectly recognisable, they calmly regard the biblical stories from afar; only once does a château thrust itself imperiously into the foreground, dominating everything else, including the devil. Festivities and colour also migrate from the secular to the religious. With unfailing taste the artists, if anything, avoided decorative excess in the worldly illustrations in order that these should never lose their air of distinction, only to unleash their full talent in the biblical scenes where oriental extravagance is perfectly suitable. And at the same time that the spiritualisation of the erotic goes hand in hand with the Mariolatry of the *Très Riches Heures*, celebrated here with such intensity and elegance, so too the advent of the Renaissance is evident in the figures of Adam and Eve and Lazarus whose nakedness — albeit the work of Netherlandish-French masters — could not be a more perfect example of harmonious, classical *italianità*.

Burgeoning spring and the fear of death: the Horseman of Death with his entourage. (Miniature by Jean Colombe)

The Duke

"This Book of Hours was made at the behest of the excellent and mighty Prince Jean — son of the King of France — Duc de Berry and the Auvergne, Count of Poitou, Estampes, Boulogne and the Auvergne." Pride of possession and the passion of the collector dictated the Duke's declaration of ownership in his priceless manuscripts. In the *Très Riches Heures*, the bibliophile's ostentation is not confined to one simple sentence but takes over the whole of the miniature for the month of January.

Jean, Duc de Berry, had titles and territories, books and buildings in abundance. His lineage was amongst the finest in the Western world. As the son of King Jean II (le Bon), of the house of Valois, he was also a descendant of the venerated Louis IX (later Saint Louis Confessor). On his mother's side he was descended from the house of Luxembourg: his great-grandfather was the Emperor Henry VII, his grandfather was King John of Bohemia and his uncle was the Emperor Charles IV. He had eight brothers, among whom were notably his older brothers King Charles V of France and Louis I, Duc d'Anjou and his younger brother, Philip (the Bold), Duc de Bourgogne. As a "Prince of the Blood" Jean de Berry was twice viceroy but, as the third-born, could hardly expect to ascend to the throne himself. That may well be the reason why he concentrated his efforts on material goods and his passion for art.

His lands included the Duchies of Berry and the Auvergne and the Earldom of Poitou in central France, as well as his own private acquisitions. From time to time he acted as the Dauphin's Governor in the vast territories of middle and southern France. In Paris he owned the Hôtel de Nesle and on the out-

The decorated borders and capitals in the Duke's manuscripts are alive with swans and bears, his heraldic emblems. His coat of arms is also often depicted.

skirts the Château de Bicêtre. In addition he acquired, built or renovated a further seventeen Châteaux in his duchies, where he stored countless precious jewels, tapestries, musical instruments, statues, paintings and manuscripts. He raised the huge sums needed for all of these possessions from taxes which he set mercilessly high in the lands under his control. He also took advantage of the uprisings, revolts and pillage spawned by war and internal rivalries and imposed high fines on the perpetrators, demanding payment for pardons. It seems only fair that in the representation of January he is not flatteringly portrayed as a sensitive aesthete. With a short nose, broad cheekbones and a sensual lower lip, here and in other portraits on miniatures and coins, the Duke is shown with the fleshy physiognomy of a robust *bon viveur*.

Born in 1340 at the Château du Bois-de-Vincennes near Paris, he grew up in the refined atmosphere of a court with musicians, poets and painters in residence, but early on he was also confronted with harsh reality. His mother died in 1349 during an outbreak of the plague, and in 1356 his father, the King, lost the Battle of Poitiers against the English, was taken prisoner and offered the whole of western France as well as a horrendous ransom as the price for his freedom. One of the forty noble hostages who had to stand surety for this in England was Jean de Berry. He was in exile there from 1361 to 1366, allowed only a few visits to his homeland under a guarantee of safe conduct. His love for an "English lady, who served the god of love" was immortalised in his emblems in the form of a wounded swan. Another of his motifs, the bear, is a reference to the patron saint of the Berry family, Saint Ursinus (Latin *ursus* = bear).

The future also held war and crises for the Duke. After the death of his brother King Charles V in 1380, Jean and his other brothers stepped into government on behalf of their under-age nephew, King Charles VI. However, barely had the latter come of age than he withdrew the Governorship from the Duke because the people of Languedoc refused to accept his pernicious

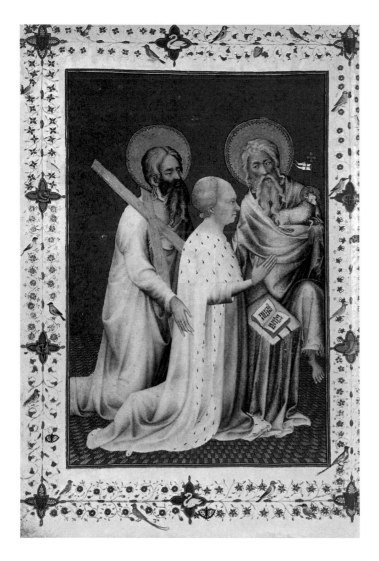

Jean de Berry with John the
Baptist and the Apostle Andrew,
his patron saint. More swans
and bears in the margin.
On the right an angel with
the Duke's coat of arms.

tax demands. But Charles VI did entrust Jean with diplomatic
missions and when, in 1392, the former began to show signs of
fitful mental illness, the Duke's voice in the Privy Council took
on new importance. With his stalwart style of mediation, he
made his mark particularly in the ever-necessary dealings with
the English, in the schisms afflicting the Church and in the
conflict between the houses of Burgundy and Orléans. As far as
this last problem was concerned, he had just reached a satis-

factory conclusion — which the King rewarded by reinstating him as his Governor once more — when the assassination of Louis d'Orléans in 1407 by the Burgundian Duc Jean's men completely destroyed all he had so far achieved. Although Jean de Berry spoke up in favour of the Duc de Bourgogne's acquittal in 1409, a year later he turned solidly against him when his own niece married the son of the murdered man. This meant that he now had the King and the citizens of Paris against him. His Paris châteaux were plundered, two of his grandsons abducted in Normandy and he himself often had to flee for his safety during the bitter struggles of the civil war. And in 1415, a year before his death, he had to face the fact of the bitter defeat of France by the English at Agincourt, where one of his grandsons was killed and his son-in-law and two other grandsons taken prisoner. From his first marriage to Jeanne d'Armagnac, who died in 1388, he had two daughters and three sons. All three sons were to die before him. There were no children from his second marriage with Jeanne de Boulogne. Jean de Berry died in 1416 in the Hôtel de Nesle in Paris and was buried in Bourges, the main town of the Duchy of Berry.

COLLECTOR AND PATRON OF THE ARTS

Political catastrophes and personal calamities were thus the backdrop to an extravagantly lavish, full-blooded lifestyle. The Duke was always on the move from château to château, taking with him his favourite books and tapestries and accompanied by his court and his artists, as well as a menagerie of dogs, bears and swans. The journey from Bourges to Poitiers, a good 150 kilometres, took roughly three days. There was a constant round of festivities and hunting expeditions, diplomatic missions, inspections of monasteries and building projects, and discussions with master builders, sculptors and painters — and

when the Duke and his companions were not on a pilgrimage, they would indulge in wild revelries.

A voracious collector — his collection of rubies was regarded as the most precious of the day — Jean de Berry was tireless in his pursuit of clocks and precious stones, paintings and tapestries, ancient and contemporary *all'antica* medals featuring portraits of emperors, and sacred objects such as communion cups and reliquaries. But he was just as keen to acquire less obvious curiosities such as one of Charlemagne's teeth, a droplet of milk from the breast of the Madonna, a giant's bone or rare animals such as dromedaries, leopards and chamois. And no distance was considered too great when it came to having some desired object sent to him, whether it was lapis lazuli from the Orient for ultramarine blue or a particular kind of mastiff from the enemy England.

But his greatest passion was for books, and in this respect he resembled other aristocrats of the time. In European court circles in the late fourteenth and early fifteenth centuries it became fashionable to be a bibliophile. The famous collectors and bibliophile patrons of the period included the Visconti family in Milan, King Wenceslaus IV of Bohemia, King Charles III of Navarre, King Martin of Catalonia, Duke John of Bedford and Duke Henry Beauchamp of Warwick, and Jean de Berry's royal relatives, Jean le Bon and his wife, King Charles V and King Charles VI. And it is highly unlikely that pious yearning for religious texts or delight in their illuminations was behind the flowering of this fashion. More to the point, finely produced books had become prestigious luxury objects — just as costly facsimiles of these works fulfil much the same function today. And it was not simply that the patron who commissioned the book could establish his own identity by having his coat of arms, emblems and portrait included in it — the whole book stood as a sign of his taste and life-style.

As did his peers, the Duke loved Greek and Roman classical literature, chronicles, courtly romances and travellers' tales. He

Decorated letter 'C' with a monk writing and a fantasy creature.

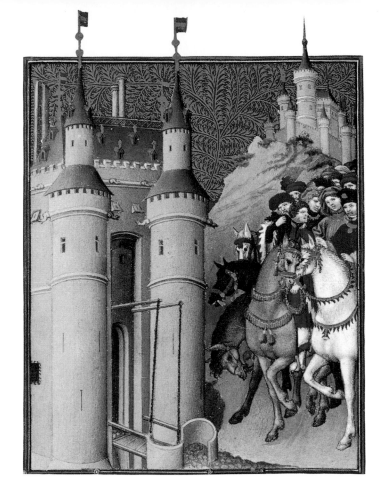

The Duke on a Journey: this miniature from the *Belles Heures* illustrates a prayer for a safe journey. It probably refers to the Duke's mediation in the conflict between Burgundy and Orléans. The blue and gold flags on the towers show this must be a Burgundian château.

acquired them either through the book-trade in Paris or privately, exchanged them or asked for them as presents. His bookbinders bound them in velvet or leather with enamelled and pearl-encrusted locks; his librarian had previously been a miniaturist. But what did set the Duke apart from other collectors and secured his reputation with future generations was the influence that he, as patron, exerted on the art of book illumination.

Above all, the Duke prized the illuminated religious manuscripts that were produced in the fourteenth century for lay devotional use in the form of Books of Hours, breviaries and extended psalters. Works of this kind that he commissioned

gradually formed a chain of sparkling jewels. He astutely chose the most able artists, laid down both the concept and details of the work he was commissioning and observed its making with intense interest, advice and corrections. His insight and enthusiasm lit the flame of his artists' inventive powers, inspiring innovation and experiment. Was it the Duke who pushed the sculptor André Beauneveu to try his hand at miniatures, with the result that the latter's plastic figures and draperies added an unusual dimension to book illumination? Was it perhaps also the Duke's idea to pair the northern painter Jacquemart de Hesdin with an Italian colleague, which led to Jacquemart's idiosyncratic synthesis of northern and Mediterranean styles? And was it persuasion — or prescription — on the part of the Duke that apparently caused the Limbourg brothers to see landscapes through his eyes? While Barbara Tuchman is certainly not unjustified in describing Jean de Berry as "mediocre of intellect and esprit,"[8] it is nevertheless clear that his feel for art was far from mediocre. Active patronage of this intensity was unusual for the time and stimulated a greater interest in book illumination. This is reflected in the fact that some art historians use the Duke's name as a reference for the high point of late Gothic French book illumination.

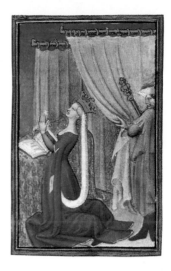

The Duke (right) and his second wife, Jeanne de Boulogne (top) in private worship. The diadem and the sceptre point to the Duke's political importance. It is not clear why the duchess is wearing a royal crown.

SIX BOOKS OF HOURS

There are six Books of Hours which, by their sheer quality, established the Duke's lasting reputation. Books of Hours were organised similarly to the official breviaries used by clerics and contained prayers for the canonical hours that were to be observed each day. In addition there would be a calendar, devotional sequences for particular days, penitential psalms, the Litany of Saints and masses for certain holy days. Their variety and variability meant that they could always be adapted to suit a particular individual's personality, with text and images re-

flecting that person's own religious observance, feast days and patron saints.

The Books of Hours of Jean de Berry are individually identifiable by the descriptive comments accompanying the relevant entries in the Duke's inventories. The earliest is the *Petites Heures* (Little Book of Hours) and was made by Jean le Noir, Jacquemart de Hesdin and others between 1372 and 1402 (Paris, Bibliothèque Nationale). Jacquemart also supervised work on the *Très Belles Heures* (Very Beautiful Book of Hours), which was finished before 1402 (Brussels, Bibliothèque Royale de Belgique). The *Très Belles Heures de Notre Dame* (Very Beautiful Book of Hours of Our Lady) was left unfinished and later divided into four sections, one of which perished in a fire. It was begun in 1385 by the "Parement Master of Narbonne" and his assistants and continued in 1405 by several other miniaturists, including the Limbourg brothers (Paris, Bibliothèque Nationale; Paris, Musée du Louvre; Turin, Museo Civico). The *Grandes Heures* (Large Book of Hours), completed in 1409, is notable for its unusually large format (40 x 30 cm). All but one of the magnificent large-scale miniatures made for this volume by Jacquemart de Hesdin are now lost, although smaller miniatures of variable quality made by other masters for the same work have survived (Paris, Bibliothèque Nationale). With the *Belles Heures* (Beautiful Book of Hours), completed in 1408/09, the Limbourg brothers created the first "picture-book" Book of Hours containing a wealth of miniatures such as had never been seen before and done with a rare degree of stylistic unity (New York, The Cloisters). And shortly after this, between 1410 and 1416, they achieved the high point of their art in the *Très Riches Heures*, although this was sadly to be the last work they created (Chantilly, Musée Condé).

The Artists

PARISIAN STYLE

Between 1380 and 1420 Paris was a mecca for artists who were attracted to the densely populated metropolis by the presence of keen aristocratic patrons of the arts and by the flowering of trade and commerce. At the time, artists still counted as "craftsmen," whose task it was to carry out a client's orders, and works of art were seen not as independent aesthetic phenomena but as having a practical use and being able to convey a particular meaning. It is telling that the most sought-after works of art were prayer-books, altar panels and gravestones — all of which were well-suited to reflecting the personality of the person who had commissioned them. At the same time, however, there were already the beginnings of a new development in that these works were starting to be produced not as the result of commissions but speculatively: this in itself was the beginning of the art trade as we know it today and was to have a far-reaching effect on attitudes to art and artists in general.

Workshops in Paris at that time either served the aristocracy, were connected to a guild or worshipful company or produced goods for the open market. Whatever the case, they were now filling up with artists from the French provinces, Flanders, the Netherlands, England, Italy, Germany and Bohemia. Different skills and modes of artistic expression intermingled and synthesised into a strikingly homogenous style: the "soft," "beautiful" or "courtly style," now generally called the "international style." It affected wall, panel and book decoration as much as sculpture and radiated from Paris out across the whole of Europe, albeit subject to constant modification. The outstanding features of this style were harmo-

The Tiburtine Sibyl watches the birth of Christ (top). The Emperor Augustus kneels at the sight of her (right). The Archangel Gabriel appears to Zacharias (top right). Flowing cascades of drapery and the S-curves in the postures are characteristic of the 'Soft Style.'

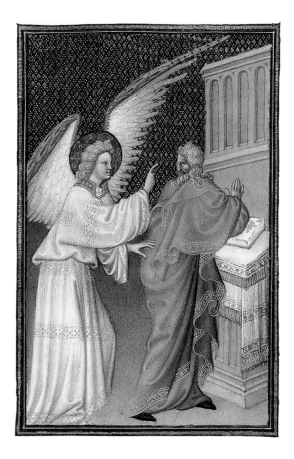

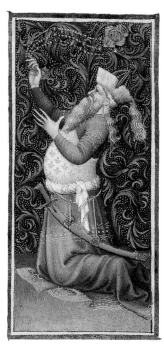

nious lineature, unified colour and noble, rhythmic movement. Figures, both male and female, were slender, described a gentle "S"-curve in their posture, had tender features and were clad in long, flowing cascades of material. The creation of space was an underlying compositional principle and was achieved by raising up the picture plane. The Limbourg brothers, in their work as illuminators, took what was already a captivating style to new heights of elegance, setting it off against a counterpoint of Italianate pictorial elements that they had encountered either in France or Italy as well as against their own style of detailed realism brought with them from the Netherlands. Like many other Netherlandish artists who found a foothold in France at the time, they became an integral part of French artistic life without ever losing their own individuality.

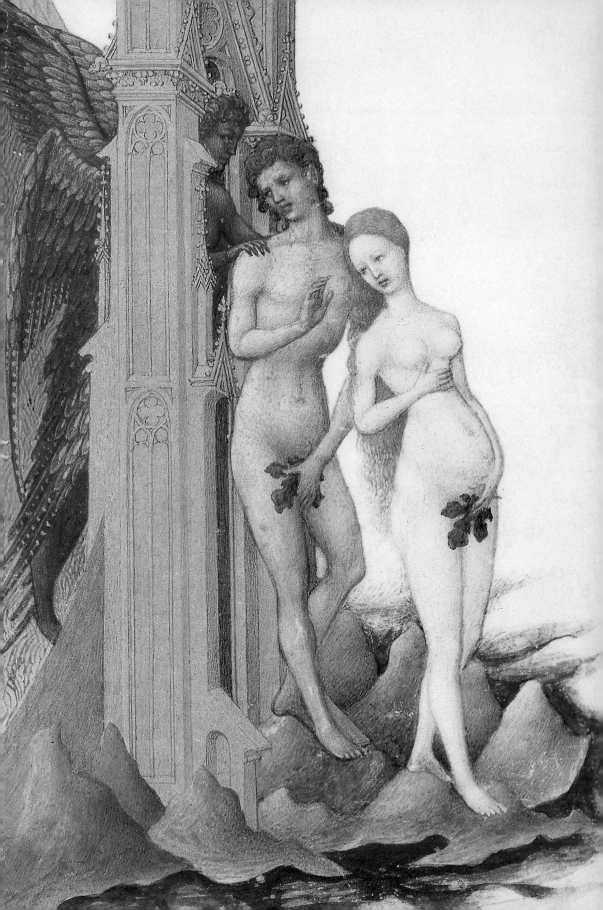

The three brothers, Paul (Polequin), Herman (Harmant) and Jean (Janequin), came from Nimwegen in the Netherlandish Duchy of Guelders between the Moselle and the Rhine. Their father, Arnold of Aachen, was a well-to-do wood-sculptor, as is evident from a document dating from 1410 in which Herman and Jean transfer property to their mother which they had most probably inherited on their father's death. Their mother came from a dynasty of painters: one of her brothers, Jean Malouel, had made his name in the service of Philip the Bold of Burgundy. It was probably on his recommendation that the Limbourg brothers were employed in the Duke's workshop and at least two of them, Paul and Jean, are mentioned in the accounts relating to the *Bible moralisée* belonging to the Duc de Bourgogne. Every statement concerning the brothers' lives has to be qualified with "probablies" and "presumablies" because the relevant documents are scarce and, on occasion, even misleading.[9] Furthermore, artists employed by princely patrons are generally only known to us by name if they emerge in court inventories or account books.

After the death of Philip the Bold in 1404, it seems that Jean de Berry soon engaged his brother's three painters. He had certainly met them in Paris, the Dukes' favourite city and where the artists presumably also worked when they were not travelling with their patrons. Paul is mentioned as working at the Château de Bicêtre and all three may well have had their workshop there for a time. In 1408/09 they completed the *Belles Heures* and they must have begun the *Très Riches Heures* around 1410. It is only from that point onwards that the sources become somewhat more informative.

As a rule they are referred to as "workers" or "valets de chambre" — bureaucratic fictions to accommodate the fact that the court treasury had no specific budget for artists, so they were listed as door-keepers, bodyguards, cupbearers and

Adam and Eve being driven out of paradise. (Detail from *The Garden of Eden*, p. 79) The ideals of beauty of the 'Soft Style': small, high breasts, a prominent stomach and a slim waist.

Could the two men with the rakish headgear be two of the Limbourg brothers? Might the man drinking be Paul Limbourg and the figure eating be his wife? They would certainly have been invited to the Duke's banquet. (Detail from *January*, p. 42)

the like, amongst whom "valets de chambre" enjoyed the highest status. It is easy to imagine that in his dealings with those in service at his court, the Duke would particularly favour these "workers" who were extremely skilled in handling vellum, the finest of hair brushes and priceless paints and could use their hands with such imagination and taste. His approach to them must have combined respect and good humour and it seems that, when the situation arose, he could act on their behalf spontaneously and even unscrupulously, as was the case in 1408 when he had Gillette La Mercier, the nine-year-old daughter of a local burgher, abducted to marry her off, against her mother's will, to "a German painter who was working for him in Bicêtre at the time"[10]: in all likelihood this was Paul because, according to the sources, he is the only one of the three brothers to have left a widow (artists from the Rhine area were often referred to as "German"). A year later the Duke gave Paul a lordly residence in Bourges and gave all three golden rings set with diamonds, emeralds and rubies, gold medallions with portraits of emperors, clothes and special gifts of money. They re-

turned the favour with artful trinkets they had made themselves and could even allow themselves a little joke, as at the New Year's celebrations in 1411 when they gave the Duke a "book" with a precious binding of velvet, silver and gold, which turned out to be no more than a solid block of wood.

Besides painters, the Duke's illuminators' workshop was home to a whole range of specialists. Since books had first been illuminated, the division of labour had been extremely complicated. The lineator drew the lines, the scriptor or calligrapher wrote the text, and the rubricator wrote in the names of the types of text using red ink (the Latin name of this shade of red, *minium*, which is also used in English, is the root of the word "miniature," not the Latin *minor* meaning "smaller"). Next the illuminators would draw and paint in the initial capitals for each verse and the line endings before they handed over to the miniaturist. It was generally only at the end of the whole process that the specialists for ornamental letters, foliage and decorative borders did their work.

Paul Limbourg was most probably the master in charge of the workshop and, in effect, its main source of inspiration. Although his two brothers enjoyed equally high esteem, Paul, mentioned most frequently in various documents, was clearly the Duke's favourite. Millard Meiss, the doyen of the history of book illumination, repeatedly stresses the inseparability of the three brothers' magnificent output, yet does identify Paul as the most innovative. Meiss saw each miniature as the work of all three brothers, and drew distinctions between what he saw as their individual input. More recent research views this theory with a degree of scepticism, preferring less definitive divisions between the three: current thinking attributes the *Très Belles Heures de Notre Dame* (illustrated here) and some other miniatures to all three, and then suggests that the brothers may have divided up the other cycles between themselves along broader lines. One may have worked on the somewhat less "modern" illustrations in the last part, another may have carried out the

representations of the months, while the third — the most outstanding of the three — created the Hours of the Passion and the eight individual plates, most of which are also illustrated here. It is of course not possible to discuss this complex issue in greater detail here.[11]

It is also not known for certain if the brothers travelled in Italy. It does seem likely that they did, however, in view of the clear influence of classical antiquity on many of their figures, as well as the Italian rather than French-looking landscapes in many of the religious scenes and, lastly, in view of the evident debt to the Sienese masters and Giotto in the composition of some of the religious miniatures. On the other hand, the artists might equally well have drawn their inspiration from the Duke's art collections and those of his relatives, all of which were rich in works of art from neighbouring Italy.

Fate, however, prevented the brothers from ever drawing fully on their astoundingly abundant gifts. The oldest was probably not much more than thirty years of age when all three died in 1416. Nothing is known about the cause of their deaths. A document in Nimwegen, dating from March 9, 1416, mentions the death of Jean, and another from September/October 1416 mentions these of Paul and Herman. In all probability they were taken by an epidemic — and, as it turned out, in the same year as the Duc de Berry.

JEAN COLOMBE AND THE FATE
OF THE MANUSCRIPT

The *Très Riches Heures* were unfinished when the Limbourg brothers died. On the Duke's death, the unbound sections of the manuscript must have gone with the rest of his personal effects to his sole heir, King Charles VI. At some point they must later have been transferred from the royal library to the library of Duc Charles I de Savoie, a descendant of Bonne, one

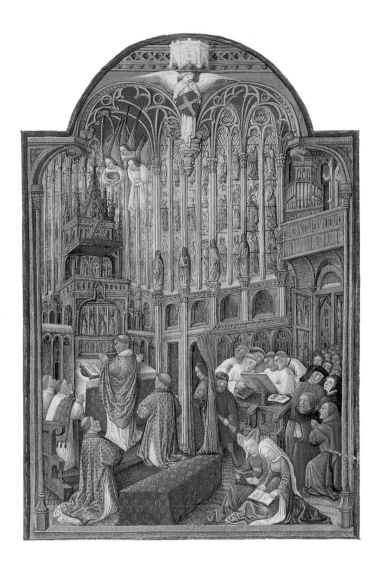

The Christmas Mass and a detail
of the lavish border decoration,
painted by Jean Colombe.

of the daughters of the Duc de Berry, since it is known that in
1485 Duc Charles I commissioned Jean Colombe, an illumina-
tor living in Bourges, to undertake the book's completion.

Jean Colombe (1430/35–90), after an apprenticeship with a
calligrapher, had become by 1470 a successful book illuminator
working for the aristocracy. With Duc Charles' agreement, he
was clear from the outset that in taking on this commission he
was not about to attempt to copy the Limbourgs' style, but
that he would finish the *Très Riches Heures* in his own style,
influenced as it was by Jean Fouquet.

33

Recent research has come to the conclusion that between 1416 and 1485 — after the death of the Limbourg brothers and before Colombe began his work — another painter at the court of King Charles VII may have attempted to complete the work.[12] This so-called "intermediate illuminator" managed to match the style of the Limbourgs but nevertheless has betrayed his hand to posterity by including some items of dress and styles of building that clearly date from around 1440. There is general agreement that the months of March, June, July, September, October and December are from this period. Since there is no proof as yet for this hypothesis and since it is of no more than academic interest here, this brief reference to the matter should suffice. Even if the existence of the "intermediate illuminator" were to prove true, it would not detract in the slightest from the artistic quality of the miniatures themselves.

After Colombe had completed the *Très Riches Heures* nothing was heard of them publicly for three and a half centuries. It was not until 1855 that the bibliophile Henri d'Orléans, Duc d'Aumale, living in England at the time, followed up a tip from an Italian librarian, also living in England, and found the manuscript in a girls' boarding school in Genoa. He immediately purchased it and made it public, generously releasing it for its first scientific examination. The codex had probably been taken to Turin in the sixteenth century as part of the library of the Savoyard house of Chambéry. Two coats of arms on its eighteenth-century binding show that it was at one time owned by the Spinola family and later still by the Marquis Hieronymous Serra in Genoa. It was eventually inherited by the Baron Felix of Margherita in Turin, who had it put up for sale. When the Duc d'Aumale returned to France after the fall of Napoléon III, the manuscript came into the possession of the Institut de France and then of the Musée Condé in Chantilly where it still is today. In his will the Duke bequeathed his château in Chantilly and all its art treasures to the Institut de France, originally founded by Cardinal Richelieu.

The Manuscript of the *Très Riches Heures*

CONTENTS AND FORM

The manuscript starts with the calendar and the representations of the months, as befitted every "classical" Book of Hours. Four Extracts from the Gospels are followed by the Prayers to the Virgin as the first of the Offices of the Church that were to be observed at set times throughout the day and night: at midnight (matins), at dawn (lauds), at the start of the working day (prime), at 9.00 a.m., 12.00 noon and 3.00 p.m. (terce, sext, nones), at sunset (vespers) and on going to bed (compline). Each of the eight Offices has its corresponding miniature: *The Annunciation, The Visitation, The Nativity, The Annunciation to the Shepherds, The Adoration of the Magi, The Presentation in the Temple, The Flight into Egypt* and *The Coronation of the Virgin*. These were then followed by the Hours of the Cross, the Hours of the Holy Ghost and the Hours of the Passion. Between these sections there are psalms with small miniatures depicting events in the life of King David. A series of Little Offices for short weekday services is followed by the Hours of the Passion, which runs, with a few gaps, from Christ's arrest to the entombment of Christ. The work is then completed with an unusually full section of masses going from Christmas to the Feast of Saint Andrew. In addition there are eight large-format miniatures of outstanding quality. These are without texts and were probably only included as an afterthought. They comprise *Anatomical Man, A Plan of Rome, The Garden of Eden, The Purification of the Virgin, The Fall of the Rebel Angels, The Meeting of the Magi, The Adoration of the Magi* and *Hell*.

The manuscript of the *Très Riches Heures* consists of 206 sheets of vellum, measuring 29 x 21 cm, in 31 signatures. Gener-

ally the signatures consist of four sheets of vellum folded in two (16 sides), in each case with the right side marked with r (recto) and the left side with v (verso). Out of a total of 131 miniatures, 66 occupy a whole page and 65 take up the width of one column. Jean Colombe is credited with 23 of the large miniatures and roughly half of the small miniatures.

The text itself — Gothic script in black ink — is laid out two columns to a page and written in a consistently even hand. It is broken up with large capitals at the start of individual verses and chapters, ornamental capitals (majuscules) and decorative line-endings. The initial capitals of each chapter have figurative designs within them and offshoots of foliage, leaves and flowers leading out from them. The border decorations are not simply the same design throughout, as in the *Belles Heures*, but — where they do occur — are positioned quite freely in the space available. Perhaps some further innovation that was never completed was intended here, which is unfortunate because what there is seems so promising. As it happens, the decorations were rarely painted by the Limbourg brothers themselves, and most have been attributed to various masters whose real names are not known.

THE CALENDAR:
COSMOLOGY AND ASTROLOGY

The calendar which opens this Book of Hours has its place in a long-standing tradition. One of the first calendars of feast days with signs of the zodiac and cult figures symbolising the months is to be found on an Athenian marble frieze from as far back as the first or second century AD. Early medieval calendars were illustrated with realistic portrayals of human beings in their daily round throughout the year, often with commentaries in verse form. A Martyrology from 969 (London, British Library) depicts exactly the same monthly activities as Books of

Anatomical Man, one of the most unusual and significant miniatures in the *Très Riches Heures.*

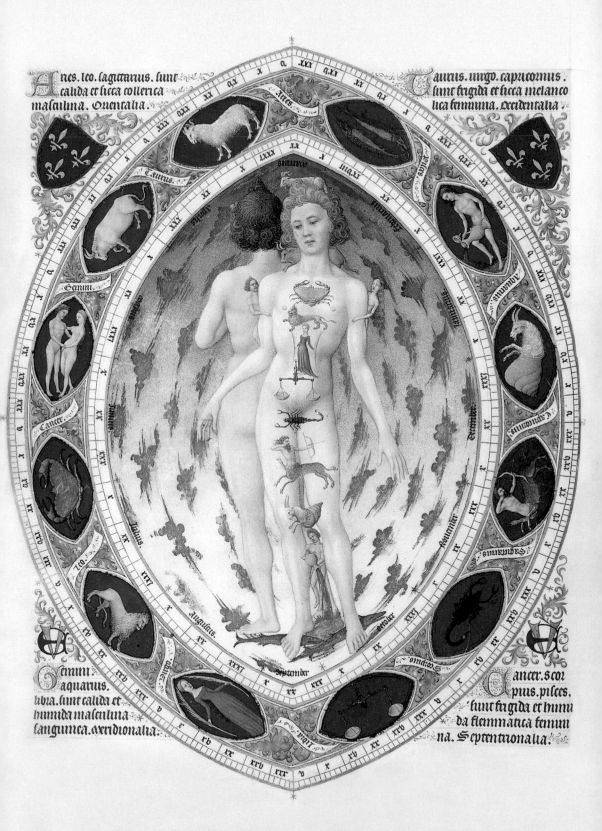

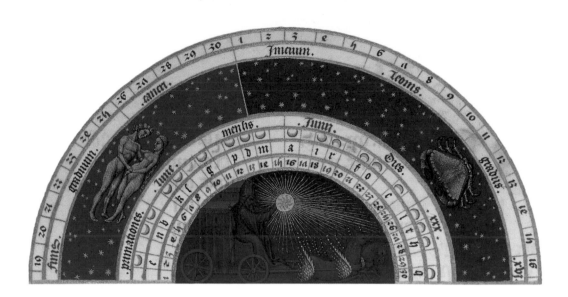

Hours from five centuries later. And in the twelfth and thir-
teenth centuries there was an abundance of representations of
the months along with signs of the zodiac on French and
Italian church portals.

The calendar section of the *Très Riches Heures* has become by
far the most famous of all by virtue of its beauty and bold ar-
tistic innovation. Even the large format is exceptional: each
double page has a calendar on the left facing a full-page illus-
tration of the relevant month on the right. Each calendar page
is divided into vertical columns showing the days of the week,
the days of the month in the Old Roman system using "nonas"
and "idus," Saints' days and religious feast days, the lengths of
the days and, in the first and the last columns, the phases of
the moon in the so-called "old and new golden numbers." Each
representation of a month depicts the heavenly bodies in two
semicircles, one set inside the other. The outer semicircle shows
the two signs of the zodiac for that month, while the inner one
always shows the same chariot drawn by winged horses bearing
an ancient ruler wearing a crown on his head and holding a sun
radiating in all directions. The crown is a kind of mitre sur-

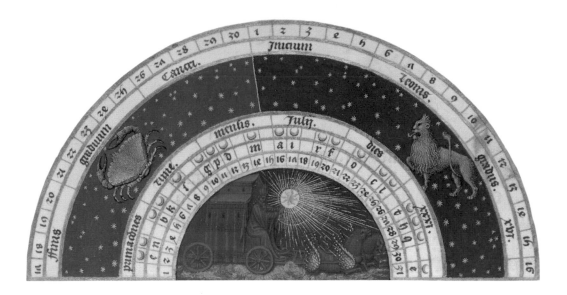

Each of the twelve representations of the months has a semicircular 'heaven' above it which shows the Lord of the universe on his sun chariot, as well as tables with signs of the zodiac and astronomical information. Some were left unfinished. The arched paintings for the months of June and July are illustrated here.

rounded by gold, like those worn by the Magi in the illustration elsewhere in the *Très Riches Heures* and clearly influenced by the gold medals in the Duke's collections with portraits of the Emperor Heraclius. Astronomical information is included in written form.

The calendar comes to a close with a full-page illustration of an "Anatomical Man" (p. 37). This fascinating image demonstrates, broadly speaking, the "medieval view of the world" where human beings, body and soul, in their thinking and doing, are bound up with the elements of the Earth and the heavenly bodies into one overarching cosmic order. From the early Middle Ages onwards, theological writings sought to clarify this by means of illustrations showing human beings at the centre of the cosmic wheel: the macrocosm in the microcosm. In addition, the *Anatomical Man* shown here is marked like an illustration for a medical text of the time: these illustrations used "microcosmos man," "zodiac man" or "veins man" to show the correlation of various parts of the body to macrocosmic or astrological constellations so that these links could be exploited for the purposes of medical treatment.

By way of a complete exception in the context of a Book of Hours, this miniature shows a double figure — male and female, it would seem — standing back to back in a cloud-filled cosmos. The mandorla around them contains the signs of the zodiac, with divisions for the days of the month (along the inner edge) and thirty degrees for each of the signs of the zodiac (along the outer edge). Small symbols cover the slender, forwards-facing female figure, from Pisces at her feet to Aries at her head — each relating to a particular part of the body — with Gemini (the Twins) peeping out to right and left on either side of her shoulders. The texts in the four corners connect the signs of the zodiac to the humours which always come in pairs and determine a person's temperament. These are then themselves linked to the four heavenly directions and to the two sexes: "Aries, Leo and Sagittarius are hot and dry, choleric, masculine and oriental; Taurus, Virgo and Capricorn are cold and dry, melancholy, feminine and occidental; Gemini, Aquarius and Libra are hot and wet, masculine, sanguinous and meridional; Cancer, Scorpio and Pisces are cold and wet, phlegmatic, feminine and nordic."

Although this miniature may well be amongst those that were not originally intended to be included in this Book of Hours, nevertheless the Duke's fleurs-de-lys and his monogram EV (as yet unexplained) do show that, whatever the case, this illustration was made for the Duke himself.

Research has shown that the particular medical illustrations to which this work is related were to provide an astrological guide for blood-letting, giving favourable times and suitable points on the body for blood-letting or other medical treatment.[13] It is reasonably likely that the Duke, over seventy when this Book of Hours was being made and certainly not unafflicted by the ailments of age, might also have commissioned "practical" tables from his artists.

In their *Anatomical Man* the Limbourg brothers created a supremely elegant work of art. The most strikingly inventive

aspect is the use of the mandorla shape for the cycle of the signs of the zodiac — a shape that was more commonly found as the aureole around the figure of Christ, the Virgin Mary or the Holy Trinity. With such a specific religious provenance, it takes on a strangely ambiguous quality in this daringly secular ap-

uch smaller scale around each of
ing a similarly subtle effect in the
nd the similarity of the graceful
e sculpture of *The Three Graces* in
en remarked upon — the use of
y of the *Anatomical Man* is new, yet

cal signs both in religious books
om this period should not, in fact,
he Christian Middle Ages, ancient
stars were modified, yet still sur-
stars as the mediators of divine
ed somewhere in the distance be-
nclusion that the heavenly con-
God the need to direct the course
eptable to theologians. Moreover,
oblems such as the fact that there
ac which might too easily be seen
ostles. Repeated imperial bans on
that the more diplomatic prelates
to integrate it into their Christian
om is that in the late Middle Ages
t in astrology, rather like in our
have been any different, in view of
orms of suspicion covering man-
with the reliance on number sym-

bolism and all sorts of other kinds of combinatory trickery? Jean de Berry may well have shared a passion for astrology with his brother King Charles V, who was nevertheless a fanatically pious Christian.

Double spread overleaf:
Calendar page and representation
of the month of *January*

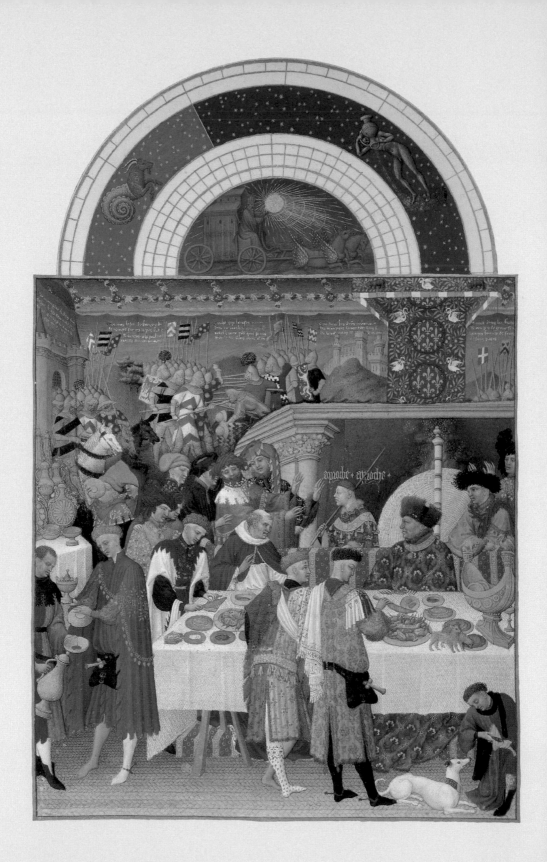

Januier a .xxxi. iour | La cinitte | Nôbre
Et la lune .xxx. | des iours | dor
 | lxxiiii. ai | nouel.

iij.				viij. rxbj	xix.
	b	iiij ꝗ	Octaues saint estienne.	viij. xxix.	
xi.	c	iij. ꝗ	Oct. s. iehan. se greneuieue.	viij. xxxi.	viij.
	d	ij. ꝗ	Octaues des innocens.	viij. xxxiij	rbi.
xix.	e	Nonas	saint symeon.	viij. xxxb.	v.
viij	f	viij id		viij. xxxbij	
	g	vij id	saint frambourt.	viij. xxxix.	xij.
rbj	b	vi. id	saint lucien.	viij. rli.	
v.	b	v. id	saint pol. premier hermite.	viij xliij.	ij.
	c	iiij id	saint guillaume.	viij xlv.	.x.
xiij.	d	iij. id	saint sauueur.	viij. xlvj.	
ij.	e	ij. id	saint latir.	viij xlix.	rbiij
	f	Idus.	saint hylaire.	viij. lj.	
x.	g	xix. kl	saint felix.	viij lv.	vij.
	A	rbiij kl	saint mor.	viij lviij	xb.
xbiij	b	rbij kl	saint maurel.	.ix. o	
vij	c	xbi. kl	saint anthoine.	ix. ij.	iiij.
	d	xb. kl	saint prisce.	.ix. v.	xij.
xb.	e	xiiij kl	saint lomer.	ix. vij.	.i.
iiij	f	xiij kl	saint sebastien.	.ix. x.	
	g	xij. kl	sainte agnes.	.ix. xiij.	ix.
xij.	A	xi. kl		ix. xbi.	rbij.
.i.	b	.x. kl	sainte emerancienne.	.ix. xix.	
	c	.ix. kl	saint babile.	ix. xxij	vi.
ix	d	viij kl		.ix. xxbi	
	e	vij. kl	saint policarpe.	.ix. xx.	xiij
xbij	f	vi. kl	saint iulien.	ix. xxxij.	
vi.	g	v. kl	sainte agnes.	ix. rxxbi	iij.
	A	iiij kl	sainte paule	ix. xxxix.	xi.
xiiij	b	iij kl	sainte baudour.	ix. xlj	
iij.	c	ij. kl	Saint metran.	.ix. xlb.	xix

THE REPRESENTATIONS
OF THE MONTHS:
CELEBRATIONS OF LIFE

Just as innovative as the *Anatomical Man* are the representations of the months in this manuscript. The Duc de Berry customarily made an entrance in all his Books of Hours: praying with his patron saints, kneeling before the Madonna, depicted on a journey to illustrate prayers for the traveller. But never before did religious humility give way to his self-projection as a worldly ruler, as in the representation of *January* — continued, as it is, in the images of his châteaux, lands, guests and subjects in the following months.

One of the few decorated capitals (the letter 'O') attributed to the Limbourg brothers. It is not a portrait but a depiction of a purely imaginative figure.

It has always been said that these miniatures of the months are a genuine catalogue of medieval life. And indeed they do present a panorama of French châteaux in their settings, as well as a journal of the luxury and fashions of knightly existence. As well as this, there is a varied display of arable farming and animal husbandry, of the grape harvest, of hunting for acorns and wild boar hunts, all according to the season. And equally there is no shortage of peasants, farmers' lads and lasses, although on closer observation they do not appear to have the sturdy legs of country folk that one might expect. And towns and townspeople? Soldiers, craftsmen, beggars or even children? With the exception of a few figures taking the air in front of the palais du Louvre, none of these are to be seen, to the extent that one can only suspect they have been intentionally excluded from these miniatures.

In passing, it may be said that the term "miniature" does not sit easily with the full-page illustrations in this work, particularly as a description of the representations of the months: each faces a calendar page and stands alone without any additional text, more like an easel painting than anything else — this in itself constituting another important innovation in the art of book illumination.

The New Year's reception at court! All the riches of the groaning board, all the golden tableware and all the colourful clothing of the courtiers gathered around like birds of paradise come together to set the scene for Jean de Berry's self-aggrandisement. Sitting close to an open fire, a fire-screen encircles his head from behind like a halo. His guests stretch out their finely bejewelled hands towards the fire in rhythmic choreography — is it not also as though they were clutching at the glow from the Duke's halo?

The place next to the Duke is not taken by his wife, with whom he had little in common in later years, but instead (presumably) by his friend, the Bishop of Bourges, Martin Gouge. With the words "aproche, aproche" the master of ceremonies bids the guests come forward to be presented to the Duke. Although mainly in profile and of rather similar ages, there have been attempts to identify them by name as relatives or emissaries. But what would their names mean to us today? Still, the idea that the two men to the left, with their floppily jaunty grey headgear, might be two of the artist-brothers has distinct appeal in that they certainly deserve a place at the beginning of their book — only it is odd that there should only be two of them in such a prominent position. If these are indeed two of the artists, then this would mean that the one drinking, with his wife behind him, would be Paul Limbourg.

In keeping with the late medieval obsession with emblems, the red baldachin is richly decorated with ducal fleurs-de-lys, bears and swans, while garments are covered with crowns and the puzzling letters "m," "r" and "tv." The martial riders who seem to be forcing their way into the scene in the background are in fact only heroic figures on a tapestry depicting a scene from the Trojan War, as the inscriptions reveal. In French tapestries and wall-paintings, illusory images of the battles of antiquity were dangled in front of knights, and the legend of Troy

Detail from the baldachin with the Duke's emblems.

45

was specially popular in France — with the knights viewing the heroes from ancient times as their own forebears. And the illusion does indeed work here in the sense that the painter has so convincingly conflated the tapestry and the real world.

Everything in this scene seems to be imbued with the luxurious etiquette of the court; a special dispensation has, however, been granted the Duke's little dogs who romp on the table, snuffling at the dishes. Clearly people were not at all squeamish about such things. And noone would think badly of the painter's wife for eating with her hands: that was the custom — even at court. There were knives for cutting and spoons for supping, but forks did not come into use until the sixteenth century. Gold vessels formed in the shape of a ship, as seen here on the right, would contain spices and substances for detecting poison, and were reserved for use by those of royal blood only.

Freezing February

When winter chills the fingertips of the occupants of the luxurious palace, this means that the land is cloaked in a covering of snow that bitterly bites and cuts through the peasant's skin. Had there ever previously been a depiction of such ringing cold to equal this scene? The covering of snow clarifies the forms both in the foreground and in the distance — whether it is the church spire, the branches or the birds. The muleteer on his way to the village and the pitiful figure in front of the tower store find their breath freezing before them: this is as new to painting as the footprints in the snow. The light is infinitely delicate and the snow seems to be alive — now bluish, now grey, now yellowish. The sky, laden with snow, hangs heavily as the smoke from the chimney wends its way meanderingly up the hillside.

The smoke comes from the farmer's house that has been opened for us like a proscenium-arch stage, showing the farmer's wife warming herself at the fire, as are the lad and the

The month of *February*

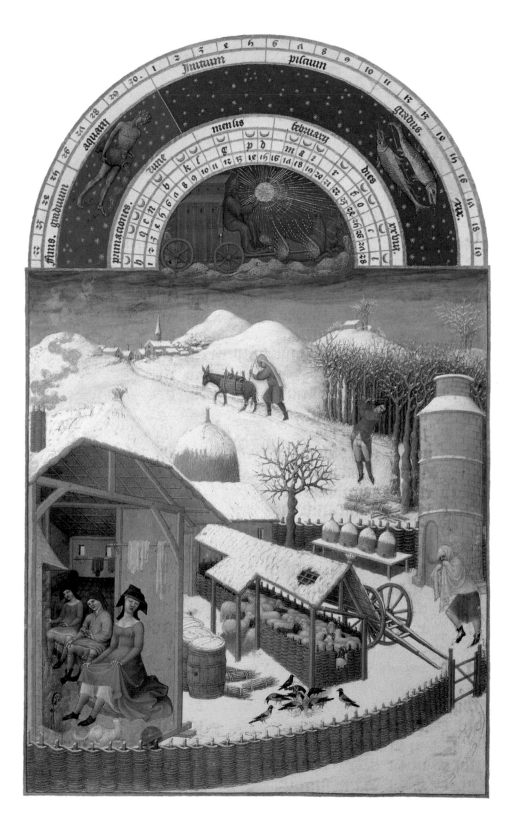

maid. While the former decorously just slightly lifts her skirt, the latter uninhibitedly raise theirs above their knees, clearly revealing that they are wearing no underwear and that they are indeed man and woman. Yet their posture is just as pleasing as the slender, finely featured, astonishingly fashionably dressed farmer's wife, whose spouse may be the figure cutting wood outside, as elegant as any golfer: farmers on stage at court!

The soft curving lines in the "international" Gothic style mentioned earlier are repeated in the landscape. An "S"-curve

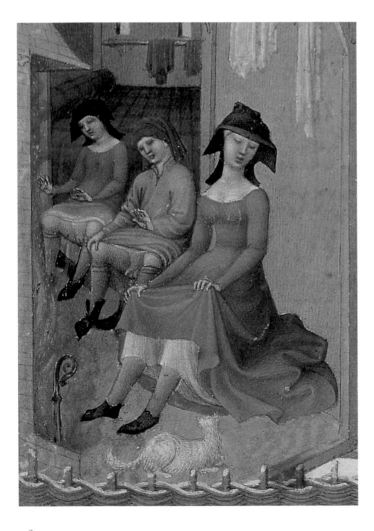

The maid, the lad and the young farmer's wife warming themselves in front of the fire, with the little dog very much part of the scene.

A medieval farm: an open sheep pen with a woven fence, bee hives, a two-wheeled horse-drawn cart, bundles of twigs and a place for feeding the hooded crows.

leads from between the hills in the background, through the village and down past the wood, to be taken up again by the tracks in the snow in front of the wicker fence. What a new sureness of touch there is in the spatial organisation of a raised landscape. And what unusual realism in the depiction of details that show us what a medieval farm looked like, with its sheep-pen, beehives, barrels, bales of straw and the feeding area for the hooded crows that only a master could have painted with such affection and accuracy.

After a frozen interlude, a bold gesture of ownership literally takes possession of the scene. From now on the representations of the months are dominated by the Duke's châteaux. His fortress at Lusignan in Poitou rolls down from its elevated position above a landscape carpeted with a pattern of enclosed fields. Paths and low walls draw the linear perspective diagonally into the background. And in the foreground, underlining the distance between the aristocracy and the peasant population, the peasant with his ploughshare and team of oxen occupies as much space as the château. In between, neatly arranged, are the vintners in the vineyard, the sower in his field and the shepherd in the meadow; even the delicate late Gothic wayside monument, the *montjoie*, has its part to play in this "political tableau" of the Duke, situated as it is at the crossroads of his strictly divided domain.[15]

The Duke wanted to see a world that was contented and entirely focused on himself, and that is what his artists depicted — and they may not even have seen it so very differently themselves. There is an almost touching concern to portray the worn clothes and the poverty of the ploughman, showing how they contrast with his noble, bent, ice-grey aspect, so reminiscent of King Lear — idealism and realism complement and contradict one another to an equal degree. But how finely the oxen have been painted and how wonderfully accurate their shadows are! After antiquity, painting had to discover all over again the fact that figures cast shadows on the ground. And the Limbourg brothers played a leading part in this rediscovery.[16] Giotto, Pietro Lorenzetti and other painters in the thirteenth century had admittedly already overcome the "shadowlessness" of the Middle Ages in that they used shading to model architectural images, faces, draperies and rock formations, and the Wittingau Master in Bohemia had already taken the first steps towards depicting shadows as cast by figures or objects,

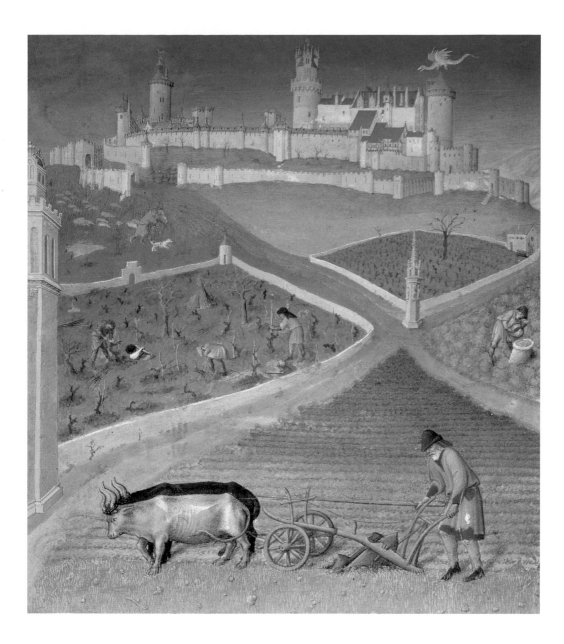

The month of *March*

but in this miniature for the first time we find fully-fledged shadows — some years before Masaccio or the Netherlandish artists Robert Campin and Jan van Eyck were to add them as an important element to their own artistic repertoires. The other side of the coin, of course, involves highlights on various ob-

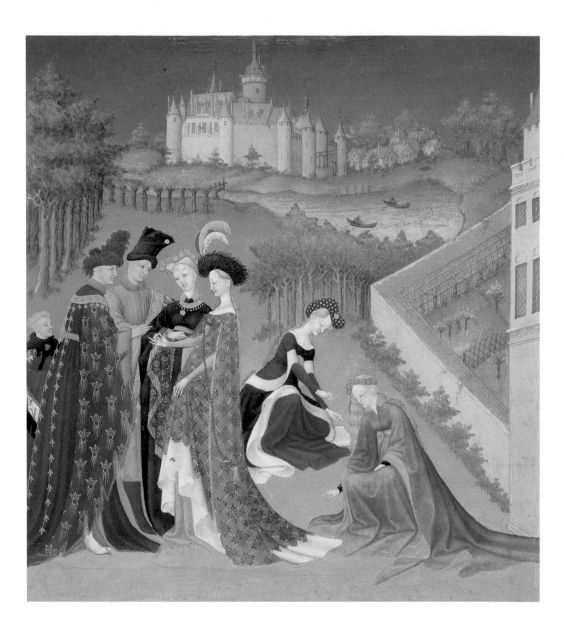

jects using "light-soaked" colour and here highlights play on
the skins of the two oxen and on the furrows in the field,
coming from a light source somewhere to the left of the viewer.
New visual delight for the Duke!

The dragon on the turret recalls the legend of the Fair Mé-
lusine that is associated with this château. As the human

The month of April

daughter of a sea-fairy, each Saturday Mélusine turned into a fishwife. She brought wealth to her husband and power and esteem to their ten sons, as long as her husband kept his oath to avoid her on Saturdays. When, however, he broke his oath in a moment of jealousy, misfortune befell the family and Mélusine fled in the shape of a dragon.

Foliage, Fine Robes and Feelings
of Love in April and May

The perfect fashion show! Under their elaborate throws, the gentleman wear different colours to left and to right, down as far as their stockings. Their head-dresses have a bizarre, oriental air and a similar style was popularised later during the High Renaissance. The ladies' clothes also create a double effect: cleverly close-fitting, sleeveless underdresses with transparent or flowing over-garments with trains and trailing sleeves or wide openings that were, with good reason, known as "fenêtres d'enfer" ("hell's windows.")

The fine ladies and gentlemen seem exotic and strange, in a tamed, green garden-landscape — incorporeal, unsmiling, meltingly beautiful. They are here to act out a solemn cere-mony. In *April* a betrothal is being celebrated and in *May* ladies and gentleman with head-dresses of leaves and green May clothes ride out, not just to mark the spring, according to the custom in France at the time, but also to take part in a prenup-tial festivity.

As the gentleman in *April* gives his fiancée a ring in the pre-sence of her parents the four figures exchange tender, eloquent glances: a moving scene which reveals little of the extent to which love and marriage were stylised at the time into courtly manners, symbolism and social play. Both scenes are flooded with light green and glowing blue — not only because it is spring, but also because in contemporary colour symbolism green stood for new love and blue for eternal fidelity. In the

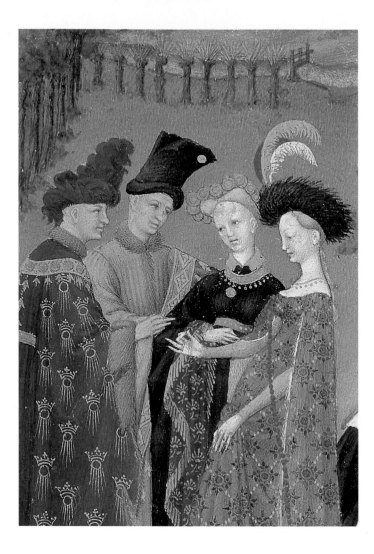

A subdued betrothal: The groom's eyes are full of questions, the bride looks away, the father's eyes are filled with sadness and the mother is lost in thought. (Detail from *April*, p. 52)

Green was the colour to wear for this May jaunt into the country: at court, the prescribed 'livrée de Mai' was 'vert gai' — cheerful green. The noblest courtiers only wore a sprig of greenery. The rider on the left dressed in red, black and white — the royal colours — may be a Prince of the Blood. (Detail from *May*, p. 57)

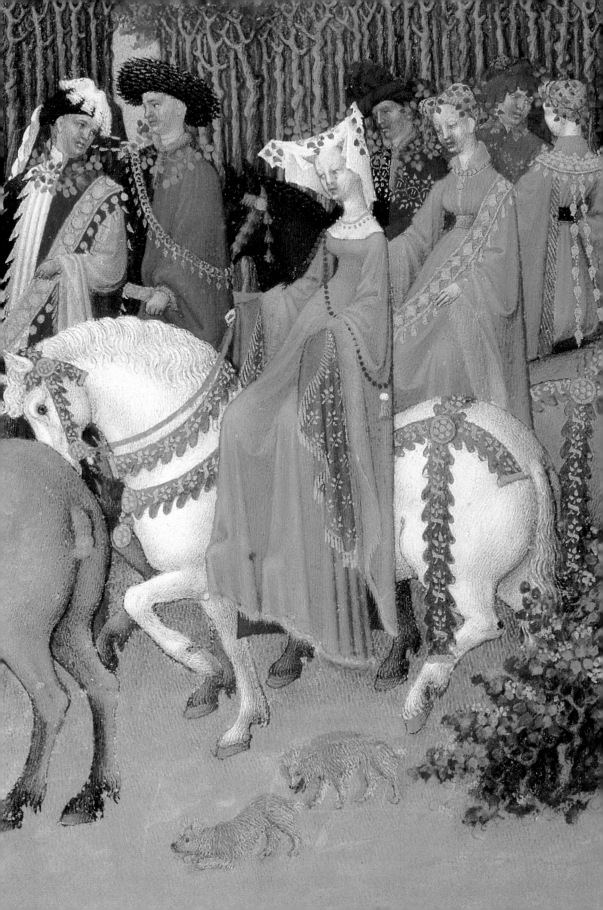

representations of the months, apart from the ostentatious gold at the New Year's reception, gold is generally reserved for the clothes of the nobility and the tips and crosses on the turrets of the châteaux. And if the expressions of the participants in these amorous preliminaries are uniformly solemn — almost to the point of melancholy — then this in itself is a part of court etiquette, the "tenue" of the aristocrat.

Persistent attempts to identify the figures that appear in this Book of Hours are perfectly understandable, even if it seems that only the image of the Duke in January is intended as a true likeness. The château in *April* has been identified either as the Duke's own Château de Dourdan between the Loire and the Seine or the Château de Pierrefonds belonging to the house of Orléans. Furthermore, it seems the occasion may either be the betrothal of the Count Jean de Clermont (later Duc de Bourbon) and Marie de Berry in 1400 (although, if that were the case, the figure of the father in grey is entirely unlike any other portraits of the Duke) or the betrothal of the poet Charles d'Orléans and the Duke's granddaughter Bonne in 1411. Thus the *May* scene has correspondingly been interpreted either as the groom (in red, black and white) and the bride (wearing green and a white head-dress) with the Palais de la Cité in Paris in the background, where the first potential bridal couple were indeed married, or as the "second" bridal couple in front of the Duke's château in Riom.

The particularly intensive green used in both of these miniatures was made in the ducal workshop from Hungarian malachite, while the blue was made from lapis lazuli from the Orient; the strong vermilion of the head-dresses and of the court jester's coat in *April* was made from quicksilver and sulphur. But what would any of these colours have been without the subtlety of the brushwork — such as that on the green trees, and on the glittering lake in *April*?

The Month of *May*

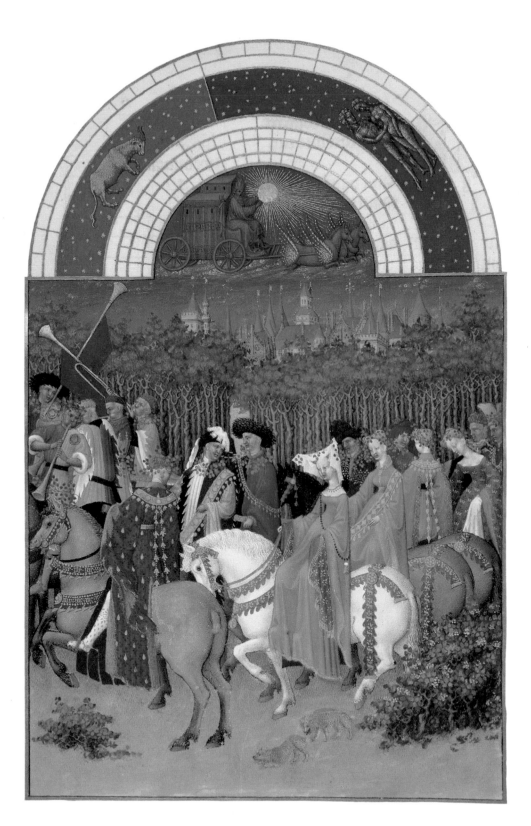

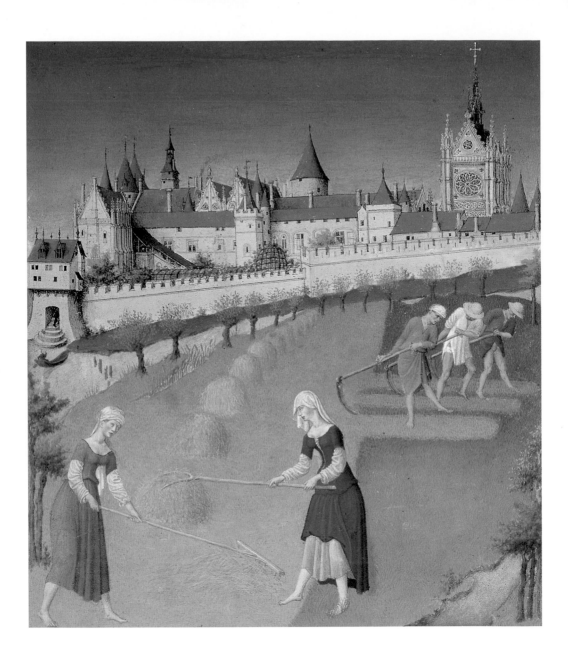

The Month of *June*

The Peasants' Summer
as seen from the Duke's Windows:
June, July and August

In *June* the Duke could look out east from the Hôtel de Nesle in Paris (now the site of the Institut de France) towards the back of the Palais de la Cité (now the Palais de Justice), which was the residence of the Kings of France from the days of the Capetians until 1416, after which time it housed the departments of Justice and Finance. With startling clarity under a hazy sky the building extends from the "salle sur l'eau," leading directly down to the Seine on the left, across to the imposing tracery of Sainte-Chapelle in the right background. A row of trees dutifully matches the curve of the wall along the riverbank, nicely staggered haystacks in marching formation strive to catch up with the trees, peasants — men and women alike — mark out the rhythm with scythes, rakes and pitchforks. This is how peaceful the summer looks from the château windows, with the scent of hay drifting in from outside. Paris — where Jean de Berry was Captain-General and where all the agony of the civil war which caused the Duke himself such suffering — seems quite to have disappeared in the distance. Here there is only room for an idyllic parallel world. And *July*, too, is just as still and untouched by the outside world, with its gold clouds in a magical sky above the Duke's château on the Clain River in Poitiers. The occasional bleating of a sheep or the clipping of shears will hardly permeate as far as the courtyard and fountain on the right, let alone the into bowers under the roofs of the crystalline triangle of the château.

These châteaux are, however, by no stretch of the imagination merely a backdrop to the activities of the peasants. Their omnipresence in the representations of the months under an eternally blue sky and the phases of the heavenly bodies lends each moment a kind of permanence, showing the year of the lord of the château, the Duc de Berry, as part of the eternal

order of the world — this is the conclusion drawn in a study of the *Très Riches Heures* which also suggests that it was not the artists who determined the view of the land they were depicting, but rather that it was their client who laid this down for them.[17]

However, this only applies to the *concept* of the secular representations in this Book of Hours, not to their artistic realisation, the quality of which is evident above all in *July*. While it perhaps seems to be constructed on a geometric grid of diagonals, diamonds and triangles, these forms abut each other with such playful irregularity that the picture space takes on a particularly lively aspect. On the one hand, there are the curves of hats, sickles, swans' necks, backs of sheep and turrets of the château, while, on the other hand, willow branches, cornflowers, field poppies and rushes compete to match the delicacy of the pinnacles and gables on the château. The only ungainly touch in this virtuoso painting is the peasant on the far left cutting the corn. He is clearly related to the knock-kneed mowers in *June*, where it is also noticeable that the two female figures in the foreground are hardly by the same artists as the rest of the scene and look much as though they have been reworked, to their detriment, by another hand.

August is the only miniature that shows courtiers and country-folk together in the same picture. And yet they still remain worlds apart. Up in the fields outside Étampes, another of the Duc de Berry's châteaux, the peasants' summer continues to burn. The harvest is underway. While some peasants still struggle with scythes, bind the sheaves and load them onto a cart, others are already refreshing themselves with a dip in a wider stretch of the Juine River. There is yet another innovation: an attempt by the artist to depict swimming figures; he has even studied — and with some success — the refracted light on the water as a swimmer climbs out onto the riverbank.

The summer pleasures of the court party, on the other hand, are cooled by the green meadows and woods. Hawking with ladies! In fact, this was the only form of hunting in which ladies

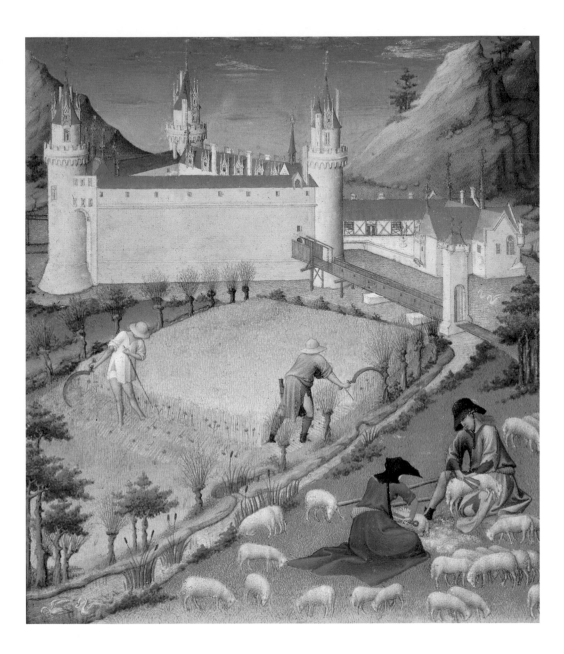

The Month of *July*

Double spread overleaf:
Every garment, every gesture is sheer visual pleasure — but the real painterly innovations are on the periphery: the swimming figures — painted on the silver surface of the water and yet entirely visible below it. (Detail from *August*, p. 64).

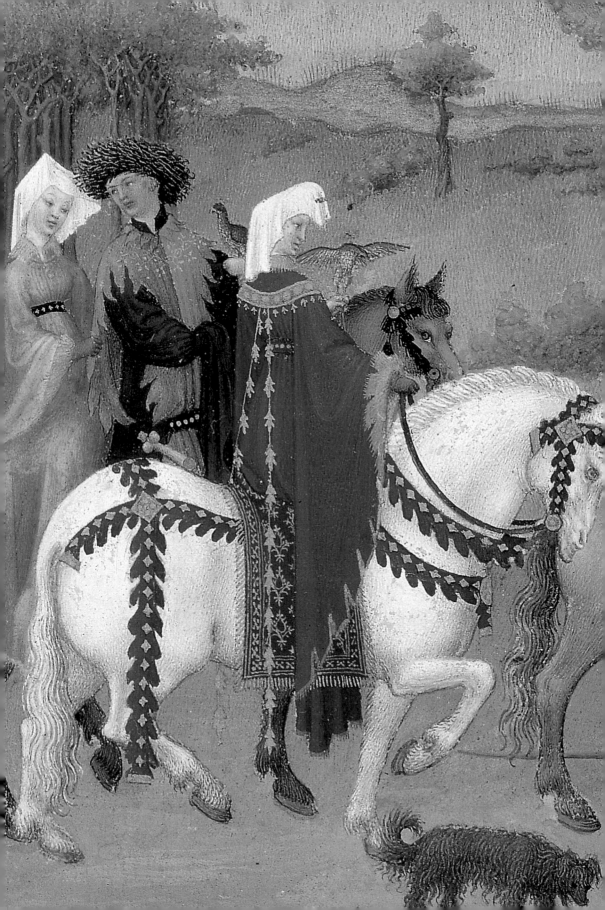

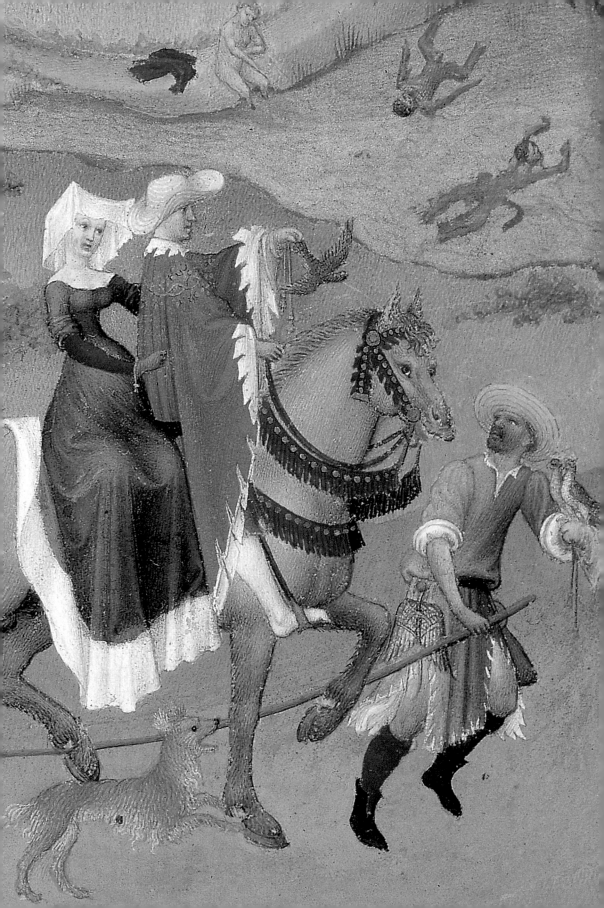

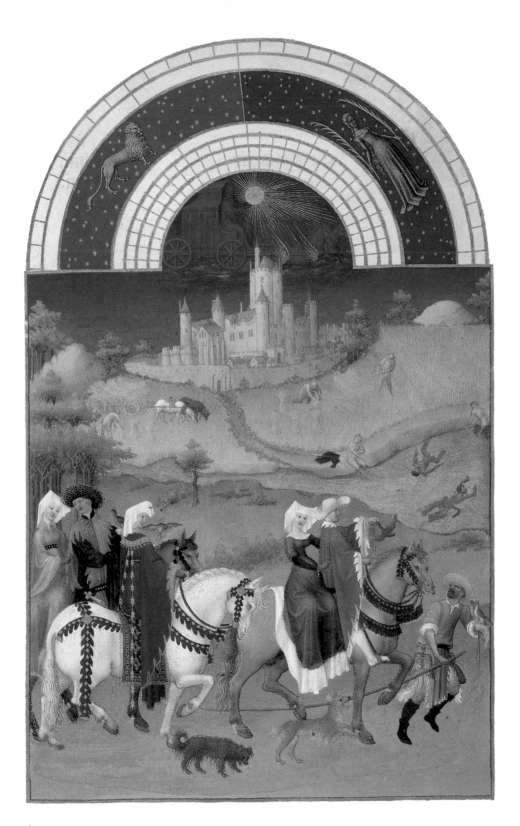

were allowed to participate, while the gentleman could become positive Nimrods in their pursuit of their aristocratic privileges as huntsmen. The main focus is on the magnificently dressed lady on the grey, preceded by a couple concentrating on their falcon and followed by another couple perhaps more interested in a tender tête-à-tête than anything else. The party is led by a falconer with two birds on his arm. The powerful undulations of the splendid procession, with the tangibly restless falcons creating a nervous ripple on the surface, are matched by the undulations of the landing rising up behind. And the captivating beauty of the different greys and blues set against delicate pink, vermilion and brown or gold, seems to imply a sense of good cheer that is hardly reflected in the expressions of the members of the hunting party.

One wonders whether the two worlds would seem to come any closer together if they were viewed from the château. The mighty twelfth-century keep, which still stands today, was known as *La Guinette* ("the lookout" or "the watcher"). Towers had names in those days, as did cannons and swords, bells and jewels — even dungeons: things treated as individuals.

Two-Handed September

This miniature of *September* is divided not only by the stark horizontal of the fence below the centre. Its colour and style also divide the scene, with the light, organic delicacy of the château above opposed to the succulent, earthy colour of the grape harvest below (p. 67). The credit for the resulting fascination and tension is shared by the Limbourg brothers, who were responsible for the fairy-tale château with its pointed turrets, and Jean Colombe who, seventy years later, firmly yet skilfully planted the vintners along with their carrying-baskets, mules, carts and vats, in the vineyard. By placing the tournament track across the centre of the scene — assuming it was not already sketched in, like the vineyard — Colombe also created a division bet-

The Month of *August*

ween the two styles. It is no wonder it is deserted. By the time he was working, the splendour of chivalry had long since faded, taking with it the pompous, eccentric ritual of the tournament.

The Château de Saumur near Angers, dating from the late fourteenth century — and which today looks much as it did then — did not belong to the Duc de Berry but to his nephew, Duc Louis II d'Anjou, who would certainly not have found favour with the Duke when his son married a daughter of the house of Burgundy. Recent research suggests that even the château itself was not painted by the Limbourg brothers but by the later "intermediate illuminator" working for King Charles VII. The King was married to a daughter of the house of Anjou and might therefore have been keen to have an illustration of this particular château. After the mid-fifteenth century the famous poet René d'Anjou, another of Duc Louis II's sons, lived at Saumur — writing and painting — with Yolande d'Aragon and took the château as the model for the "pleasure dome" in his novel *Le Livre du Cuer d'Amours Espris*.

*Ordering the Fields and Taking
the Air in October*

A sack of corn, a scarecrow archer, a defensive turret and the round dungeon of the Louvre, all placed directly under the sun of the cosmic coachman — pointing down into the depths of the earth and upwards into the high reaches of eternity: what could this be other than an homage to the life-giving, protecting, enlightened power of the King (p. 71)? The Duke's gaze — and, with it, that of his artist — is directed here north from the Hôtel de Nesle to the Louvre, the King's residence at the time, built around 1200 by Philippe Auguste as a fortified residence within the city walls. In the late fourteenth century it was converted by Charles V into a multi-turreted château, which is faithfully recorded in this illustration, showing how it looked

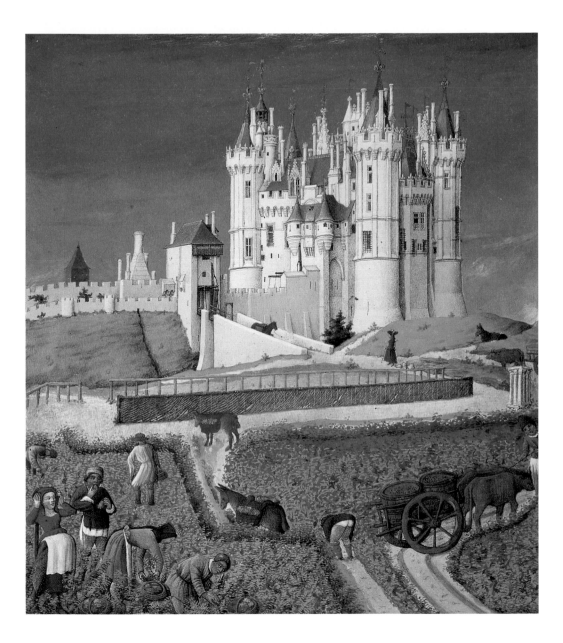

The Month of *September*

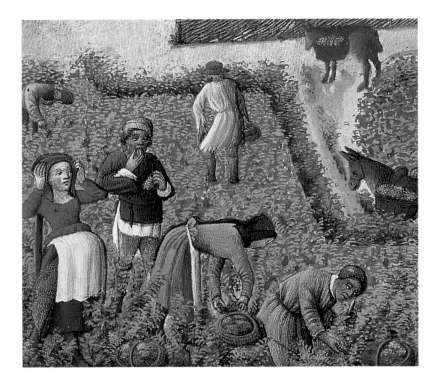

The light, filigree Château de Saumur — still a fairytale castle today —
was painted by the Limbourg brothers. The robust peasants in the vineyard
were added seventy years later by Jean Colombe.

before its radical rebuilding in the sixteenth century. The "don-jon" was particularly important in that it was the repository of the crown jewels and was also the place where special privileges would be conferred on the King's subjects. This accounts for its "elevated" position in the miniature — and why should the corresponding "lower" focal point in the fields not be occupied by a scarecrow dressed as an archer? After all, it was not as though the Duke and his painters were entirely without humour.

Down below, under the immovable hundred watching eyes of the château, time and motion take their course: the sower follows the furrows to the right, the harrower on horseback crosses towards the left, and the magpies and crows at the lower left edge of the field cluster around the grains of corn, from which they are kept away in the other field by the scarecrow and a fine, trembling net. Washerwomen beat their clothes in the Seine, boats pass down the river while others are moored at the quay, and strikingly well-dressed city-dwellers are reflected in the water as they stroll along the promenade talking to each other or observing the activities on the river or in the fields. And each figure — from the magpies and the horse to the tiny form against the château wall — casts its own fleeting shadow, while every furrow, every tree, every stone in the fields and every area of exposed skin responds to the play of the light as it falls.

The composition is equally sensitively orchestrated with horizontal lines creating the feeling that this is only one section of a larger scene, while implied diagonals on either side of the central axis draw the eye into the distance. The diagonals are formed by the edge of the field on the left, the harrow, the steps up from the river, and even by the bent posture of the sower who, like others, looks more like a disgruntled flunkey from court than a peasant; by contrast, the other peasant and his horse seem contentedly earthbound. The land draws flatly back into the distance, the colours that are so strong and glowing in the foreground become ever paler and the figures

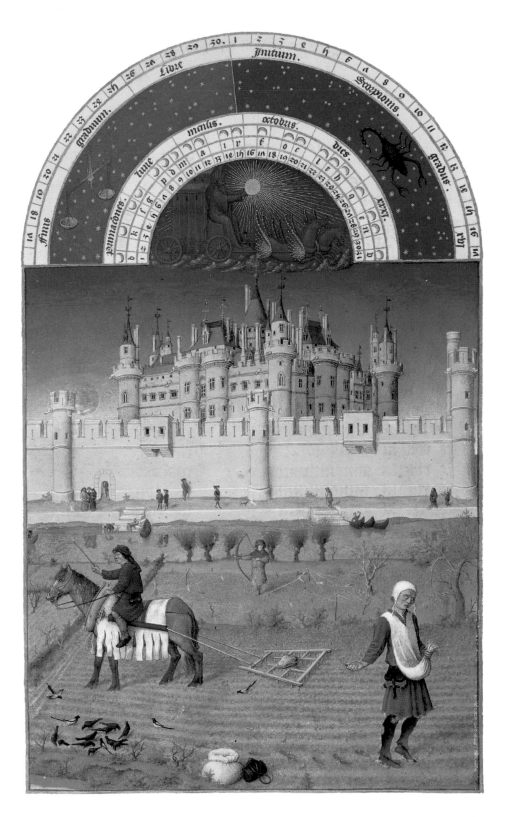

become ever smaller. And then the beholder's eye is challenged to scale the wall — so resistant in its very flatness — behind which rises up the château, so solid and three-dimensional. This striking conflict between surfaces and depths may interestingly enough be interpreted as a conflict between modes of orientation: namely, that prescribed by the Duke to the painters and that which they were in the process of discovering for themselves.[18] Of course this bravura miniature must be attributed to Paul, the most gifted of the three brothers.

The long shadow of the scarecrow in the field (below), the shadows cast by walkers on the path or on the walls of the Louvre, even the reflections in the water — the Limbourg brothers were instrumental in the rediscovery of shadow and reflection in painting after antiquity.

Preparations for the Duke's Table
in November and December

Jean Colombe — was it not he who positioned such brightly painted, lifelike vintners in the vineyard in *September*? And now in *November* he sets a heroic actor with gold-edged tunic centre stage, doubtless swearing eternal love with pleading gestures to

the lady of his heart hidden amongst the trees (p. 74). But, of course, in reality a pig herd is throwing a stick up into the oak trees in order to dislodge acorns to feed his decidedly under-nourished swine. Or is it the painter rather than the pig herd who is at fault here?

If the Limbourgs' successor may have somewhat over-styl-lised the traditional November motif of the acorn harvest — slightly losing his way with the gold highlights on the pig herd's clothes and the foliage — nevertheless the miniature is still effective, particularly in its landscape elements: the shaded trees, the tree-covered rock formation behind the fantasy château, and the chain of mountains disappearing into the blue distance, no doubt depicting the Savoyard landscape of his client, Duc Charles I.

And the wild boar hunt in the *December* miniature (p. 77) would also bear fruit for the Duke's table that we gazed on in such wonder at his New Year's reception in the *January* scene.

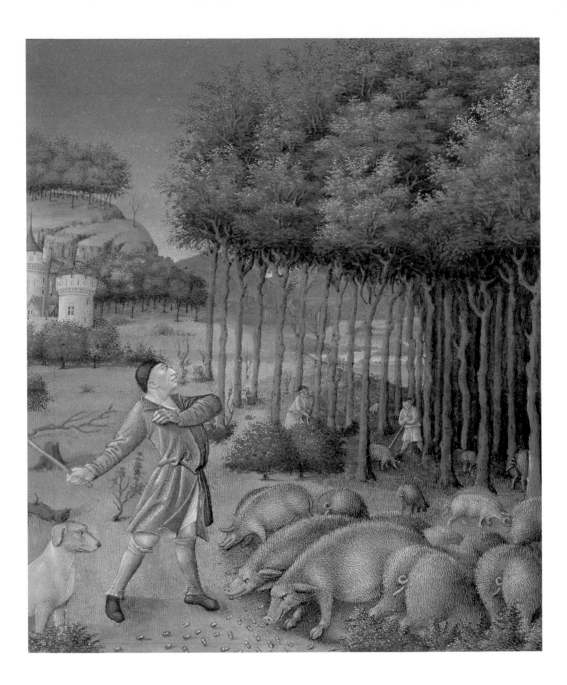

The Month of *November*

Now we find ourselves in an old royal hunting ground, in a wood by the Château de Bois-de-Vincennes, east of Paris, where the Duke was born on November 30, 1340, just as December dawned. At that time the mighty dungeon in the centre was still under construction, with the nine towers being added by his brother King Charles I some twenty to thirty years later.

The drama of this scene is incomparable. The wild boar has just been brought down and the pack of hunting dogs is falling ravenously on it, for they have earned a part of the prey as their reward for the chase. The hunt servant on the right blows the hallali (from the French *ha la lit*, meaning "there it lies"). The huntsman in the centre attempts to calm one of the hounds who is wild with greed and slavering at the mouth, while the man on the left can barely restrain his leashed hound any longer. Like the figure with the hunting horn, he has a lance with a "hog head" in his left hand, and is wearing the same red, black and white as the groom in *May*. Since hunting was a privilege granted only to the aristocracy, these must either be the King's own huntsmen or those of his noble guests.

In this miniature the Limbourgs have once again displayed the full range of their brilliance. The acorn harvest, the slaughtering of swine and the boar hunt were all traditional December motifs, but a visualisation of the moment when the hounds are let loose on the boar is only known in one other example, namely in a Lombard sketchbook from around 1398 which the brothers clearly knew of in some form. The blood-lust of the hounds, the trembling eagerness in their glassy eyes and their coats stretched over sharply protruding bones are all portrayed with breath-taking realism right down to the last detail, as are the huntsmen, wild fellows with staring eyes and brutal features. Highlights and shadows shape the huntsmen's faces, the animals' coats, the stones and the branches lying on the ground in the clearing, the fine, slightly twisted tree-trunks and the wintry, pale brown leaves on the trees that enclose the violent scene like a semicircular palisade.

75

A moment of animal greed,
depicted in gripping detail.

Above the horizontal line of the trees the towers of the châ-
teau rise up into the eternally blue sky of the *Très Riches Heures*,
as though their sole purpose in being built so four-square had
been to figure fifty years later in a miniature by the Limbourg
brothers and to set the blunt solidity of their stone against the
seething confusion of the animals in the wood below.

The Month of *December*

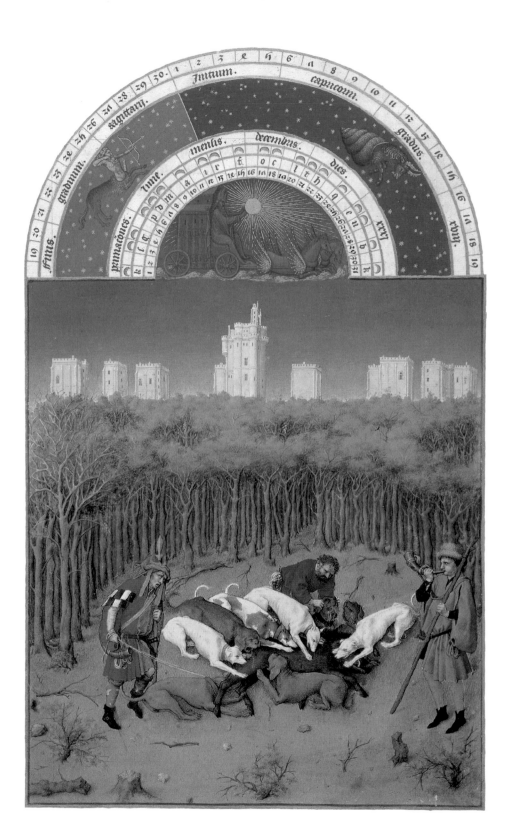

BIBLICAL STORIES:
THE GLORY OF FAITH

The luxury of the lifestyle that permeates the calendar minia-
tures — even when a peasant's knee is poking through a hole in
his hose — is continued in the illustrations of scenes from the
Bible, in a wealth of colour and gold of a glowing intensity that
even outshines the Hours of the Passion. Whether the Duke
was more interested in visual delight or religious devotion would
very much be a question for our own time, and certainly not
one for his time when "the existence of a visible image rendered
any intellectual justification of the subject wholly superfluous"
because any notion "in the form of a visual image translated
directly into belief."[19]

And in these images of such seductive decorative beauty, are
there not also moments of real earnestness that open hearts
and eyes? Eve, after the fall from grace as she hides the hand
that took the apple. The ancient King Melchior, who, kneeling,
kisses the toe of the Christ Child. The depths of sadness on the
face of Christ carrying the cross and looking towards His
mother as she blesses Him. The violent gesture of the soldier in
the same scene. The knowing loneliness of Christ on the night
of His arrest (pp. 81, 103, 101). And all of this in the context of
"pre-psychological" painting and with each face covering an
area of no more than a few millimetres.

While the representations of the months, which were
amongst the last miniatures to be completed for the *Très Riches
Heures,* are particularly notable for their advanced style, the
biblical scenes are equally notable for their sheer variety. Here
the Limbourg brothers had the opportunity to portray
Heaven, Earth and Hell, to compose crowd scenes and groups,
to depict occidental and oriental physiognomies and to devise
clothes and draperies for saints, emperors, monks, soldiers,
women and children, to invent angels and devils and to inspire
their border decorators to grotesques and *drôleries* and detailed

The Garden of Eden

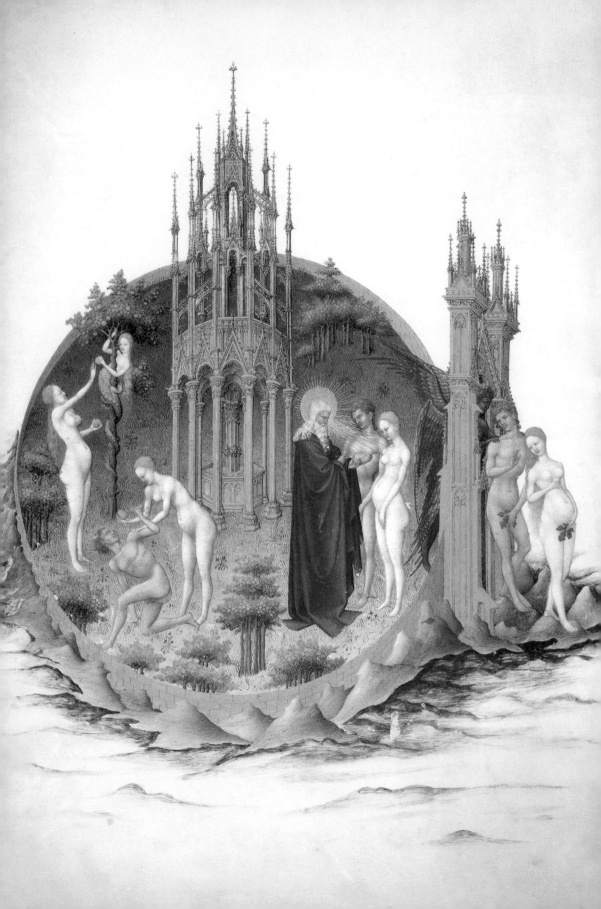

studies of flowers and tiny creatures. There are also "old-fashioned" elements in this section — some of the ornamental backgrounds of the kind the brothers had used in the *Belles Heures*, or the landscapes in the medieval style with strangely skewed, conical hills interspersed by outlines of unreal towns.

The similarities to easel painting, which have already been mentioned here in connection with the representations of the months, take on a specifically religious aspect here. Clearly showing the influence of contemporary altar panels, in these biblical scenes the artists add to the height of the miniatures using semicircular or rectangular extensions, sometimes also adding semicircles to the sides of the image. The extensions accommodate God, throngs of angels, upwards-striving archi-

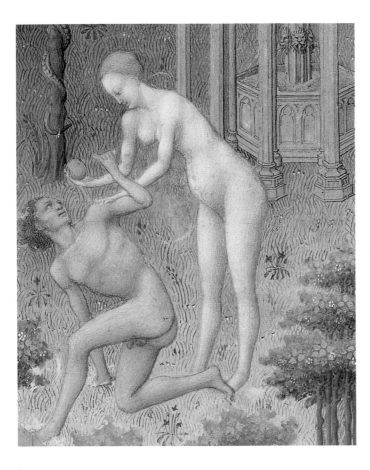

In this portrayal of the Fall from Grace, Adam turns his back on the tree with the snake. Does he really not know where the apple came from that Eve offered him?

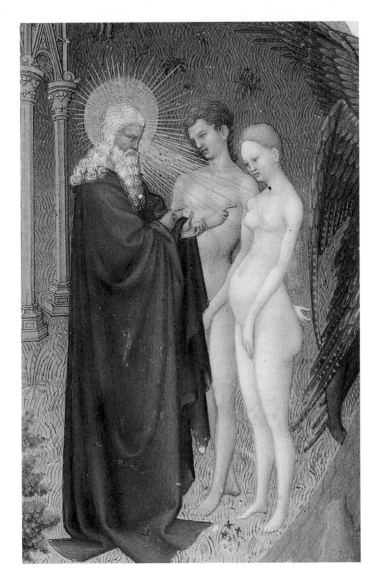

God the Father counts out on his fingers the pains that he must inflict on Eve, although golden rays from his halo are touching her at the same time.

tectural elements and additional figures crowding in from the sides. Many of the large miniatures occupy a full page, while others include two columns of text, each four lines in length.

The selection illustrated here concentrates mainly on the miniatures by the Limbourg brothers for the Hours of the Virgin and the Hours of the Passion. Other notable individual scenes by the Limbourg brothers, taken from other Offices, give a sense of the immense variety of this manuscript.

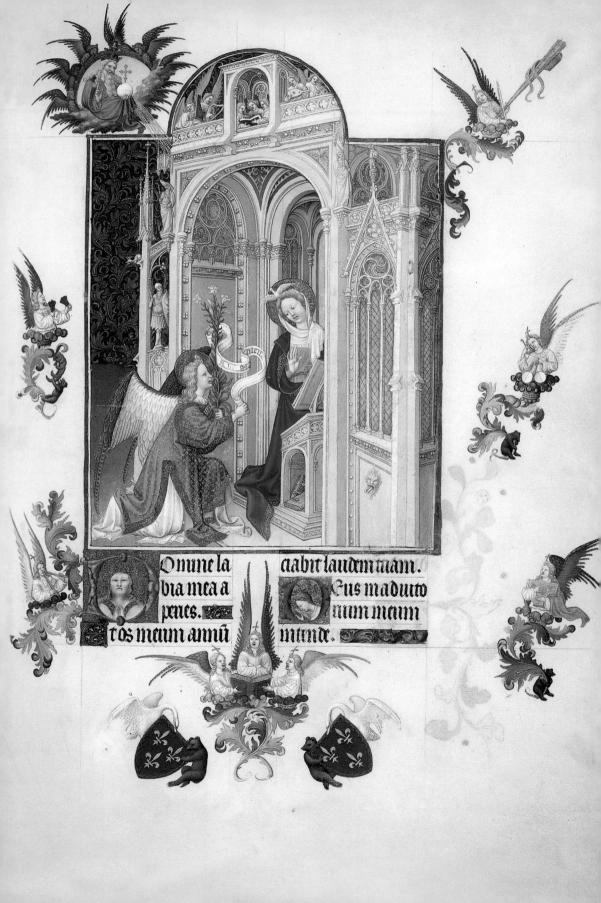

It is as though the golden rays coming down to Mary from Heaven bring with them the music of the spheres and, indeed, in the margins of *The Annunciation*, angels are playing stringed and wind instruments, bells and a harp. The golden rays are coming from the mouth of God — a symbol of the Word made flesh — and they penetrate the walls, roofs and windows and strike Mary's halo, her blessed form, the stable, the shepherds, the Child on the straw — which in these Hours of the Virgin is a pure gold vessel carried by cherubim, dazzlingly reflecting the rays back upwards. Garments, vessels, halos and angels' wings all shimmer with gold. Few other painters employed this "metaphysical" colour with such sensitivity. The marvellously pure blue of skies, garments and backgrounds, on the one hand, and the gold, on the other, together form a "colour chord" that dominates these miniatures.

In the *Très Riches Heures*, *The Annunciation* is preceded and faced by *The Garden of Eden* showing the fall from grace and Adam and Eve being driven out of the garden (p. 79), vividly demonstrating a theological connection between the two events that had already been made by the Early Fathers. *The Annunciation* marks the beginning of the story of the salvation of mankind, and the painless birth of Christ removes the curse that was cast on Eve in the fall from grace. The "Ave" with which Gabriel greets Mary is the Latin name *Eva* read backwards and thus the Virgin becomes a "new Eve." In art history this parallel is found from the thirteenth century onwards; in Italian pictures from around 1400 Eve and the serpent are not infrequently found below the enthroned Madonna.

Eve takes the apple from a serpent in her own seductive image; with an irresistible gesture she then offers the apple to Adam who is kneeling in the grass, turned away from the previous scene (p. 80). Next, the couple are overcome with shame at the fatherly rather than damning judgement of

The Annunciation

83

God the Father — although Adam is pointing towards Eve (p. 81) — and lastly the angel gently drives the couple, now hiding their nakedness with fig-leaves, out through the gates of paradise (p. 28). These four scenes are contained within a green, gold-speckled island surrounded by magical mountains and seas, forming a flat "S"-curve around the Gothic architecture of the well of life and the gates of paradise. In the midst of all the religious and courtly "costumes," it is breath-taking to see Adam and Eve portrayed as completely natural naked figures — Eve, with her small, high breasts and pronounced stomach and bottom according to the ideals of beauty at that time; and Adam, in his half-kneeling pose in the second scene, who could be a statue from antiquity. This is a magnificent miniature: generously composed, succinctly formulated, so pure of form and so light of touch.

The Garden of Eden, generally accepted to be a late work, is followed by an earlier work, the lyrical *Annunciation* (p. 82), with Mary, serious and tender, expressing reverence and mild shock in her gently raised hand and with a meltingly childlike Gabriel "wearing," as one would have to say, the most luxurious wings imaginable. Since the 1380s it had been customary in France to transpose the Annunciation from Mary's chamber to a church. The glass panes, penetrated yet unbroken by the rays from above, symbolise her virginity, and it was only artists such as Melchior Broederlam, the Limbourg brothers, the Master of Flémalle and Jan van Eyck who had mastered the art of depicting light itself and could therefore attempt this motif which was already familiar from written sources.[20] The Old Testament figures who often decorate the lectern have been re-positioned by the Limbourg brothers on the façade of the church: in this case the figures probably represent Gideon and Isaiah, whose attributes — the fleece and a blossoming twig — connect them with Marian symbolism.

Around the image angelic musicians float off from the gallery, poised on baskets of flowers, and even throw leafy tendrils

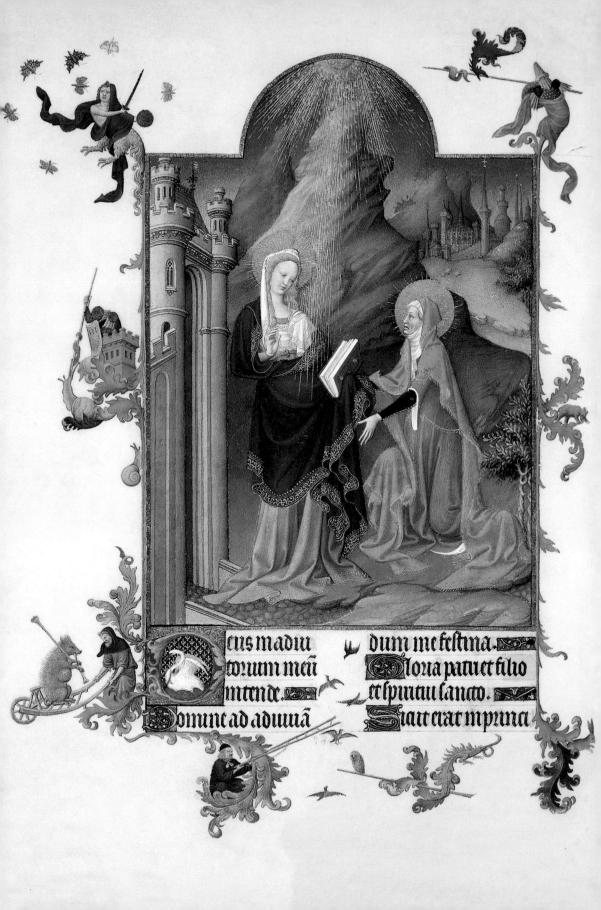

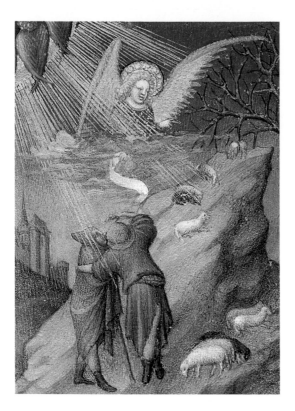

to the Berry bears: it is possible that the miniaturist and the border decorator dreamt up this idea together. The latter is known as the master of the breviary made for Duc Jean (the Fearless) and by the time he comes to do the next full-page miniature in this work his decorations are placed completely away from the scene: a merry band of butterfly-fighters, snail-slayers, bird-catchers and bear-servants arranged around a dignified *Visitation* (p. 85).

The meeting of Mary and the older Elizabeth before the house of Zacharias in Judaea is memorable for its dignity. Mary stands as tall as the crenellations on the house, and Elizabeth — the future mother of John the Baptist — has stature despite

The Nativity

The Annunciation to the Shepherds is already portrayed on the hills in the background before becoming the subject of the next miniature.

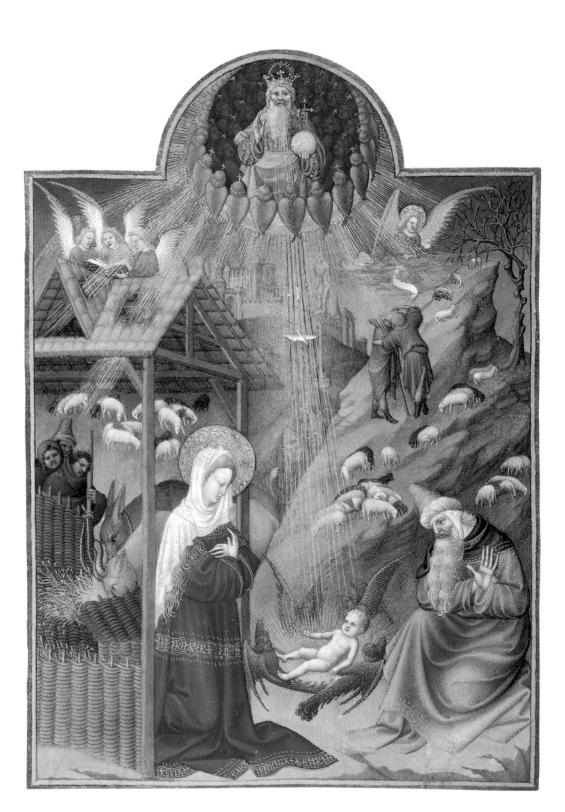

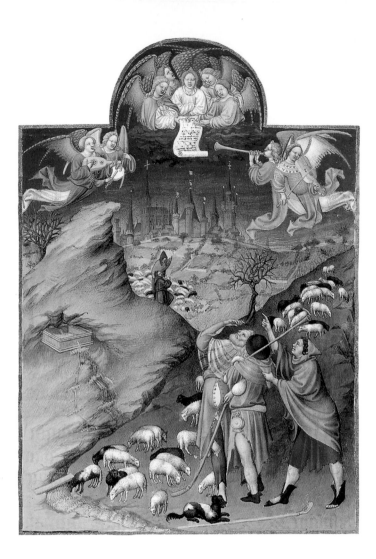

her kneeling position. With clear foresight she sees before her the mother of the Saviour, while Mary simply contemplates the book she is holding which in itself draws particular attention to the centre of the picture — an unusual touch in any representation of the Visitation. The composition consists of three large triangles, with smaller ones in the background, and is typical of Paul's work, the most talented of the three brothers. The town in the background has been identified as Bourges.

The Annunciation to the Shepherds

The Duke's towns (here presumably Poitiers) as the backdrop to the Bible story: the Duke's wishes were the inspiration for the painter's idea of having the fata morgana of the town rising up beyond the patchwork of fields.

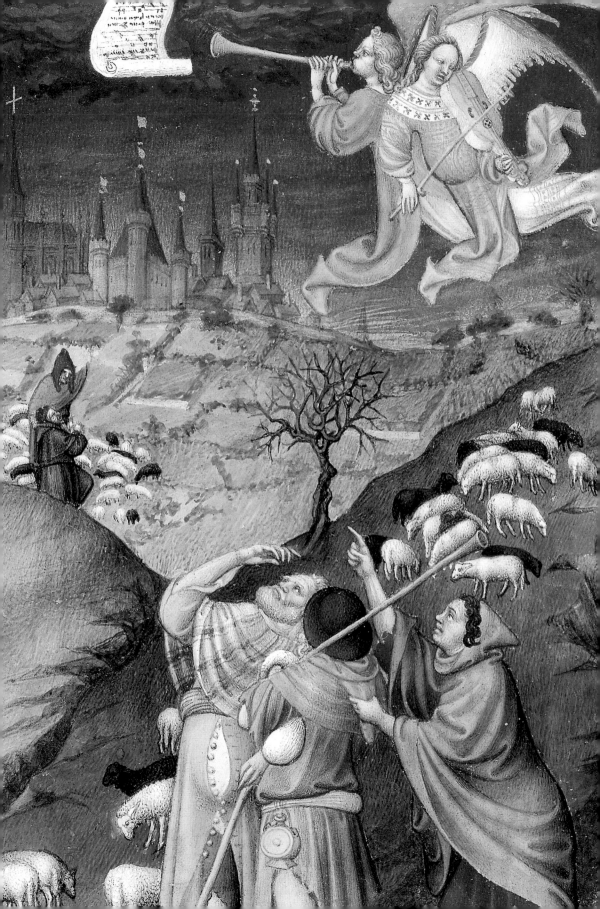

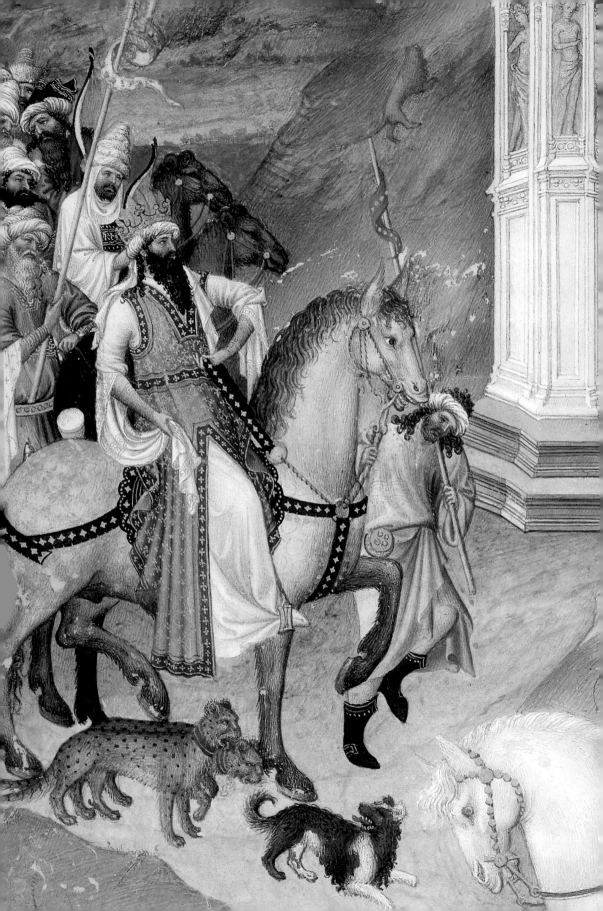

The wealth of colour in *The Visitation* (p. 87) gives way to a positive shower of gold in *The Nativity*, where the Lord's aura stands out prominently against the blue of the cherubim — blue being the colour of divine wisdom. The idea of combining the birth, the radiant light and Mary and Joseph worshipping the Child goes back to a vision of Saint Bridget of Sweden which became known soon after her death in 1373 and which influenced the iconography of the Nativity: in Bridget's vision Mary gave birth in a trancelike state, unaware of what was happening to her until she suddenly saw the Child, glowing with an ethereal light, lying on the ground before her. In this Nativity the Jew's hat worn by Joseph is taken straight from the Old Testament.

The finely portrayed shepherds on the hillside in *The Nativity* (p. 88) are brought closer to the viewer in *The Annunciation to the Shepherds*, which is given a whole miniature of its own, devoted entirely to angels, shepherds and sheep and which has a wholly new style of landscape with layers of fertile fields receding into the distance and a many-turreted town on the horizon — most probably Poitiers in the Duchy of Berry. The scene is filled with magic details: the scroll of music the angels are playing from, the animals' special drinking trough, the shepherd's clothes bursting open and the owner's marks on the backs of the sheep.

But now for milling crowds, jostling figures, strings of turbans and seas of faces! The Magi come from the East to worship the Christ Child. Two full-page miniatures celebrate this riot of colour and costume, vividly reflecting contemporary ideals of beauty in their splendour, movement and exoticism. In *The Meeting of the Magi* (p. 92) the Wise Men approach from different directions, each with his own entourage. The scene is so effectively theatrical in its construction that one dare not ask whether in reality the different processions are not in imminent danger of rushing straight past each other despite the golden, beckoning, heathen female figures in the Gothic way-

An oriental tumult forms the entourage following Balthasar as he rides imperiously ahead. Heathen idols decorate the Gothic wayside monument and Paris glows in the background. (Detail from *The Meeting of the Magi*, p. 92)

Page 93: *The Adoration of the Magi*

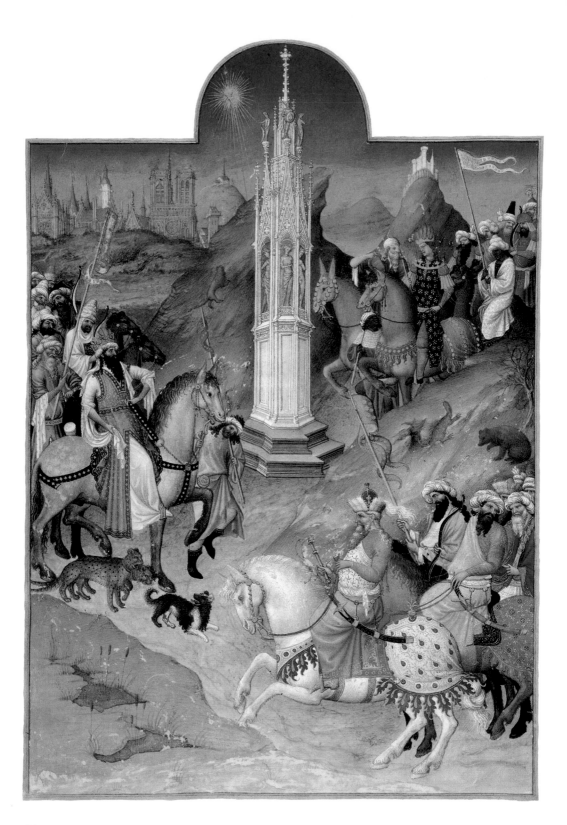

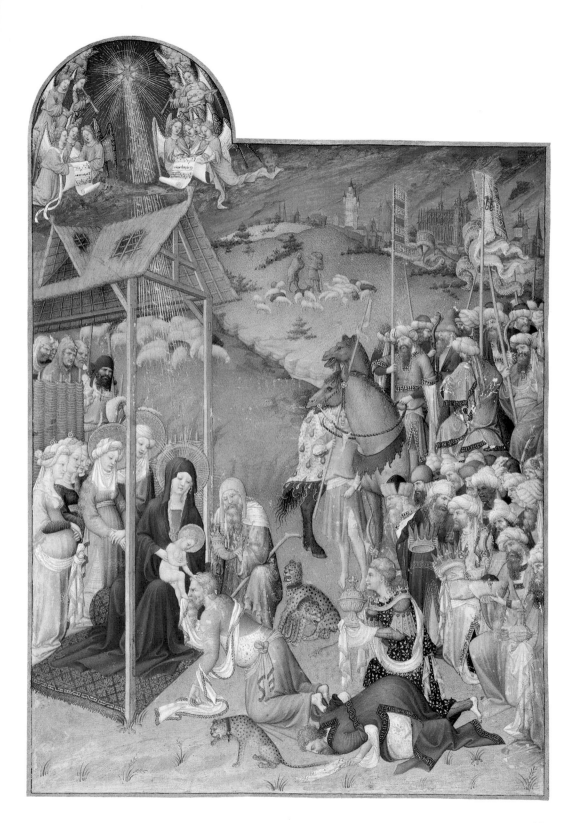

side monument — another *montjoie*, as seen in the *March* minia-
ture. Equally, the lion climbing up the mountainside in a strange
manner leaves something to be desired. On the other hand, no
artists had portrayed *The Meeting of the Magi* before the late four-
teenth century, so there were few models for this motif. This
oriental melee of sultans, blackbeards, standard-bearers and
different-coloured skins is set against the skyline of Paris
which, in conjunction with the Berry bear in amongst cheetahs
and camels, firmly reminds the viewer of the Duke's import-
ance in all of this.

The Byzantine Emperor Manuel II Paleologus was on the
move in Europe between 1399 and 1403 to seek support against
the Ottoman siege of Constantinople. During his two-year stay
in Paris he became friends with the Duc de Berry and was even
a guest at the wedding of the Duke's daughter Marie in 1400. In
this miniature he can be recognised as the figure of Melchior
entering from the right wearing a crown with a fur trim similar
to that of the Duke in *January*. On the left, the black-bearded
magus in the prime of life is Balthasar, whose features were
inspired by the portrait of Constantine on the medal owned by
the Duke. In the background, the beardless magus representing
Caspar and wearing a collar of gold lilies has been identified as
Charles VI.[21]

In *The Adoration of the Magi* (p. 93) the exotic cavalcades are
penned in, crowded together, positioned up the slope on the
right-hand side, layer for layer like a multicoloured human
tower. Far below the high viewpoint two regal figures prostrate
themselves, linking the Babylonian multitude on the right with
the Holy Stable on the left: golden vessels and halos form a
pyramid. On bended knee Melchior kisses the toe of the Christ
Child as the latter blesses him and Joseph shows the Child the
Wise Man's gift. Balthasar lies prostrate, with his face to the
ground in the oriental manner, while a servant behind him
holds a vessel containing his gift of myrrh. Caspar, kneeling,
presents his gift of incense in a Roman covered chalice. The

All eyes are directed towards the
Child; even Gepard gazes in fas-
cination. It is as though a garland
of movement flows from the
kneeling and prostrated adoring
figures through to the nimbus
of female figures: a masterly
composition. (Detail from *The
Adoration of the Magi*, p. 93)

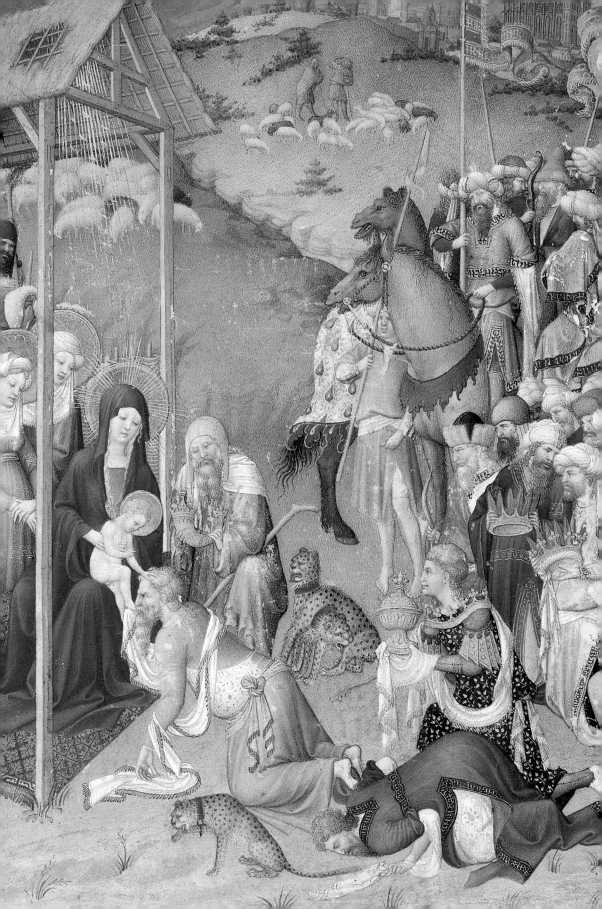

three Magi are now bare-headed and the three blessed women in the stable are crowned with halos, while the very stable itself is bathed in the light of the Heavenly aura, which also reaches across to the right in the form of golden clouds above the town of Bourges, which has replaced Bethlehem.

It is hard to know what to admire most here: the audacious composition or the strong yet highly differentiated variety in the colouration of the clothes — splendour and subtlety in a stable!

In *The Purification of the Virgin* the picturesque costumes and extravagant head-dresses might look as though they have come straight out of some imaginary Old Testament picture-book, but in reality the composition is a slightly altered copy of a fresco by Taddeo Gaddi in Santa Croce in Florence: the brothers may have seen a sketch for this in Paris. According to Mosaic custom, forty days after the birth of a son, the mother was to be purified in the temple by presenting the child and making an offering. In this miniature it is as fascinating as it is irritating that the girl bearing the offering has slipped into the focal point, rather than Mary and Joseph with the Child — seen standing at the foot of the steps — or the High Priest at the entrance to the temple, itself a splendidly painted example of Florentine architecture. The result, however, is that the viewer's gaze is led swiftly in a variety of different directions towards groups with men and women and with children who look like tiny adults.

The cycle devoted to Mary closes with *The Coronation of the Virgin*, a magnificently festive finale to the day (pp. 98, 99). Encircled by golden angelic wings and saintly halos and seated on a throne of angels is the crowned figure of Christ, with the three crowns of the Holy Trinity above Him. Christ blesses the Virgin kneeling before Him, while an angel holds a crown in readiness. This constitutes two innovations in the iconography of the fifteenth century: firstly, the link between the Coronation of the Virgin and the Holy Trinity and, secondly, the fact

The Purification in the Temple

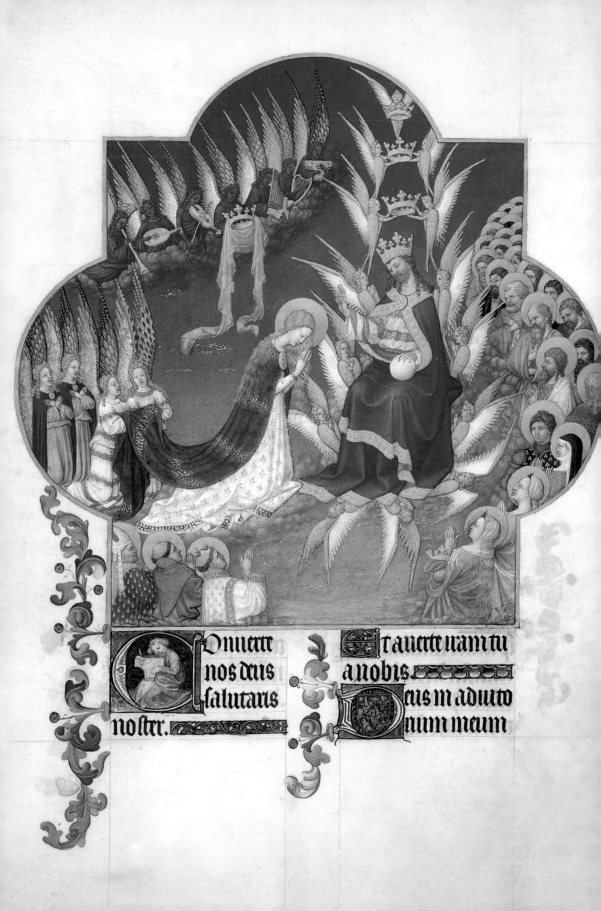

Onuerte
nos deus
salutaris
noster.

Et auerte iram tu
a nobis.
Deus in adiuto
rium meum

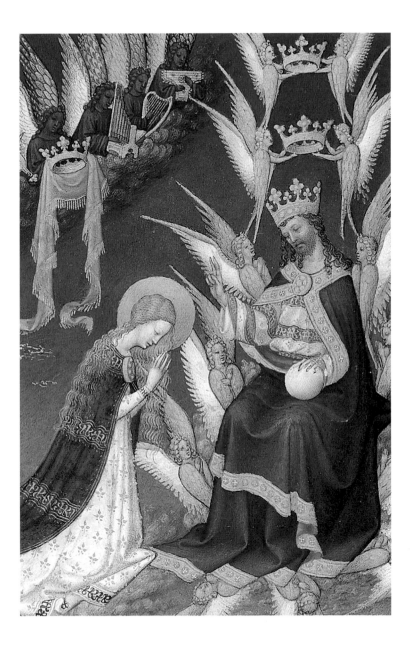

The Coronation of the Virgin

The carmine-red robe of the Virgin, the coronation by an angel rather
than Christ, the tower of crowns as a symbol of the Trinity: all iconographic
innovations introduced during the 15th century.

that Christ does not Himself place the crown on Mary's head. Various saints can be identified in the procession on the right: Peter and Paul with their grey hair, Saint Clare in her nun's habit, Saint Catherine with a bare neck. Below them, a Queen with a crown round her wrist clasps her hands in prayer. The unusual frame, with its three conches, the long flowing "S"-curves of the composition and the exquisite combination of transparent blue with shades of gold, purple and white, lend this miniature an air of grandeur and solemnity.

Dramatic Passion

The Hours of the Passion were left unfinished and subsequently completed by Jean Colombe. However, seven of the individual full-page illustrations — with neither borders nor text — may be attributed to the Limbourg brothers. Their unified, advanced style would seem to suggest that only one of the three brothers worked on them.[22] These dramatic scenes from the Passion, of which five are illustrated here, span the extremes of intensely glowing colour and sombre, nocturnal darkness.

The first miniature of the sequence, *Christ in Gethsemane*, is renowned as "the most beautiful night scene ever painted by a miniaturist. It is striking in the moving simplicity of its composition as well as in its nocturnal effect."[23] "I am he": when the soldiers and Judas came to seek Christ on the Mount of Olives, these three simple words caused His pursuers to abase themselves before Him — a rare motif in representations of the arrest of Christ. The carefully composed confusion of the figures on the ground is fitfully lit by a lantern that has fallen to the ground, two torches and Christ's halo, in its form anticipating the three crosses of Golgotha and echoed in the three shooting stars in the sparkling, starry sky above — a high point in the visual poetry of these miniatures. The mild, upright figure of Christ is majestic in its solitude, as Saint Peter, who has cut off

Christ in Gethsemane

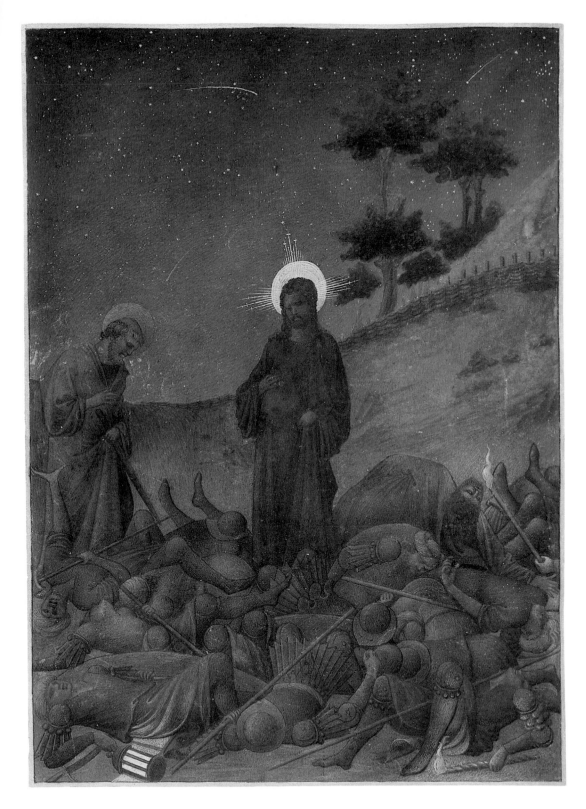

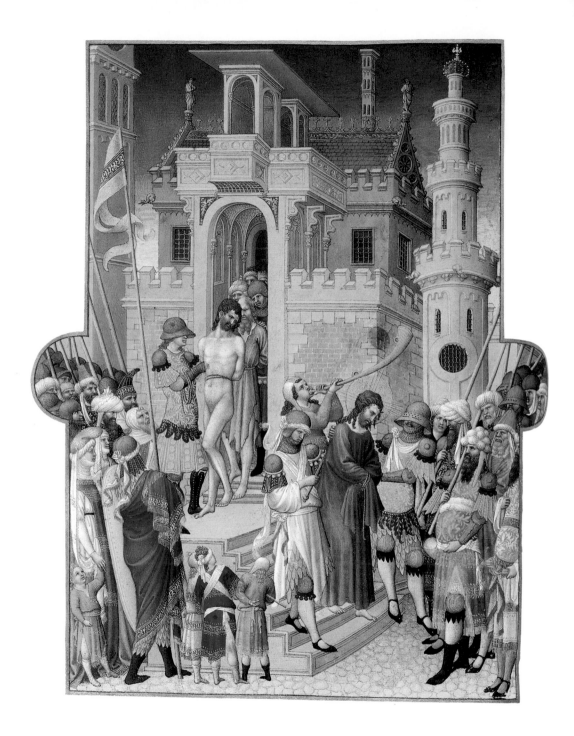

Christ Leaving the Praetorium

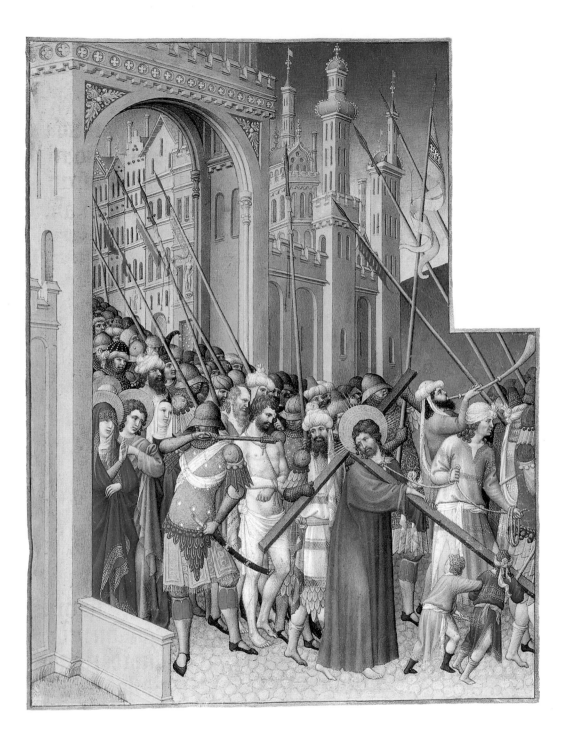

The Road to Calvary

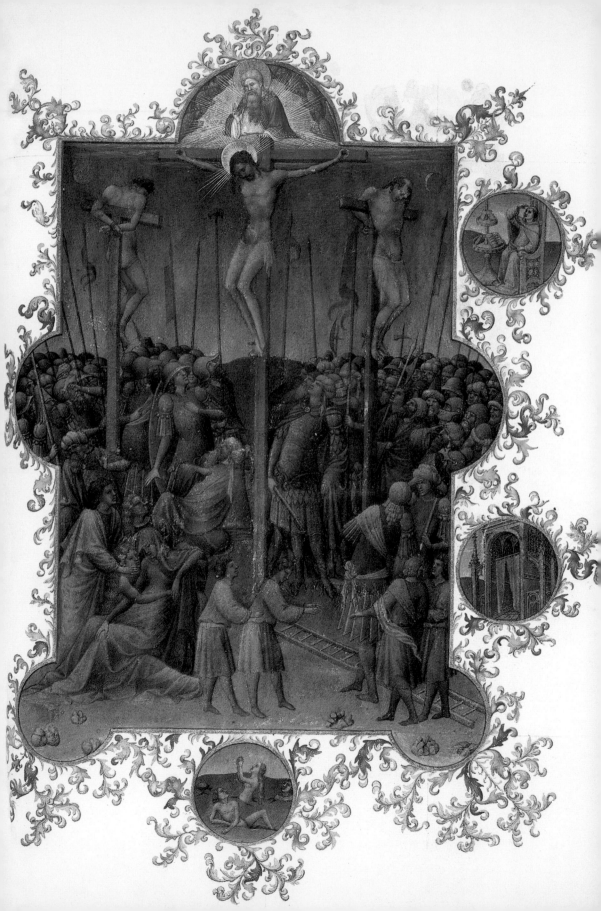

the ear of Malchus, hesitantly sheathes his sword. Peter's halo is painted in matt silver — another of the many details that bear witness to the brothers' unfailing mastery in their use of colour. This unforgettable nocturnal scene was to be the fore-runner of an even "more nocturnal" *Arrest of Christ* in the Book of Hours by the Turin Master (Hubert van Eyck?).

By contrast, in the broad light of day, *Christ Leaving the Praeto-rium* and *The Road to Calvary* (pp. 102, 103) are flooded with colour. No less virtuosic are the tightly packed crowds, skilfully depicted in a restricted space using diagonals and rounded extensions on either side of the picture frame — an innovative development of the incipient crowd scenes in Italian trecento representations of the Carrying of the Cross and the Cruci-fixion, and one which could only be matched at that time in France by Jacquemart de Hesdin. And, in all of this, there is still the same degree of detail in the inexhaustible variety of

The Death of Christ

physiognomy and imaginative costume — even the soldiers' decorated uniforms gleam with gold, while the light also catches the shimmering silver of their helmets and weapons.

In response to the cries of the crowd, Pilate condemned Christ to death by crucifixion, along with two thieves, "wretches" who follow close behind Him in both these miniatures. The one in front, presumably the "good" one, is naked, young and handsome and with deep sadness in his expression. In the scene at the Praetorium he occupies a prominent position. Pilate's palace and the high, narrow, gabled houses in *The Road to Calvary* would look more appropriate in a Nordic town and contrast theatrically with the Eastern faces below. The diagonal poles above the apathetic crowd, pointing in the direction of the procession, are blocked by the crossbeam of the Egyptian T-shaped cross carried by Christ, like a plea for a moment of rest, a plea mirrored in the pain-ridden glances that pass between Christ and His mother who is blessing Him, having stopped with John and the other two Marys at the citygate.

The Death of Christ does not portray the same darkness as in the earlier nocturnal scene: here the scene is veiled by the dull, flickering, sulphurous half-light of a miraculous eclipse, with both the sun and the moon visible in the sky. The grisaille effect is "coloured" with faint touches of blue, orange and red which also reflect God's aura above the head of His dead son. Although there is a slight awkwardness in the forced immobility of the scene, there are, nevertheless, few representations of the crucifixion that convey as compellingly as this one the fact that this is not a tragedy but a miracle. Only Mary has swooned in agony, while the young people — who oddly enough only appear in the Hours of the Passion — seem quite unmoved. All the rest look upwards, transfixed and astounded or deeply affected, as though they too suddenly see what the Centurion sees as he touches his heart with his hand and cries out, "Truly, this was the Son of God." The medallions show an astronomer trying to discover the cause of the eclipse, the torn

The Deposition

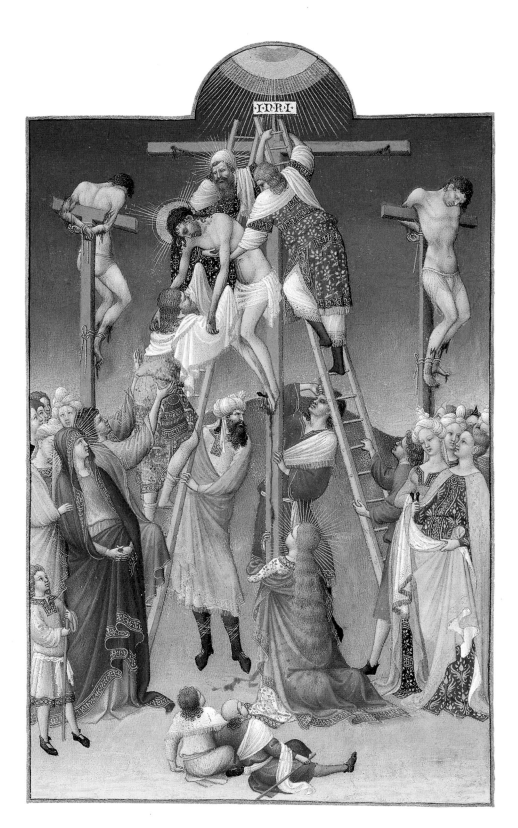

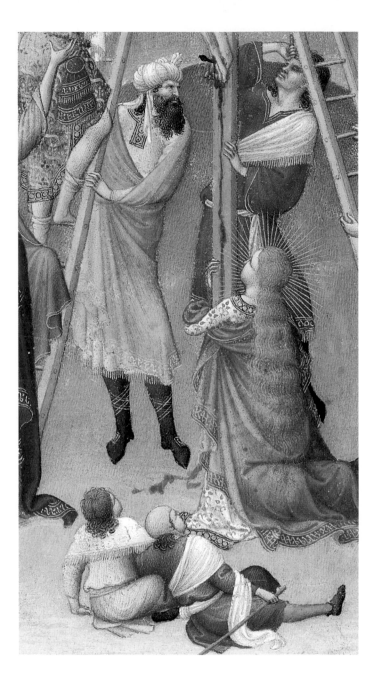

In the *Deposition* the group around Maria Magdalena
is the perfect picture within a picture.

curtains of a temple, figures rising from the dead and rocks that have fallen to the ground in an earthquake.

Lastly, there is the supreme splendour and elegance of the colours in *The Deposition* (p. 107). In this intimate group — without the thronging multitudes seen in the other miniatures in this cycle — the artist creates an interlocking rhythm of figurative triangles within a larger triangle. And the harmonious "colour chord" of blue and gold, characteristic of the Limbourg brothers, is accompanied here with bold triads of vermilion, wine-red and pink. To the left is a young Mary, motionless and composed, along with John, stretching his hand out to Jesus and Nicodemus, who together with Joseph of Arimathea buried Christ. As had been the custom since the fourteenth century, Mary Magdalene is positioned at the foot of the cross. To the right are the women who were also present at the birth of Christ. The superscription on the cross with the initials "i.n.r.i." (Iesus Nazarenus Rex Iudaeorum = Jesus of Nazareth, King of the Jews) had been customary in Italian illustrations of the Deposition since the thirteenth century, but the Limbourg brothers were probably the first to introduce it into France.[24] Both *The Road to Calvary* and *The Deposition* were influenced by the works of Simone Martini on the same theme and which may still be seen today in the Musée du Louvre in Paris and the Koninklijk Museum voor Schone Kunsten in Antwerp.

Angels, Demons and Two Miracles

Lunging, turning, hurtling and diving, they plunge into the ocean like burning torches. Lucifer, still crowned as the Bringer of Light, bores headfirst into the Earth like a comet, ignites and is engulfed from head to toe in golden flames. Even God the Father, with a blue and red halo of angels, burns gold and red, sending out rays that reflect against the angels' choir, stalls and on the armour of the Heavenly Host in the clouds. The

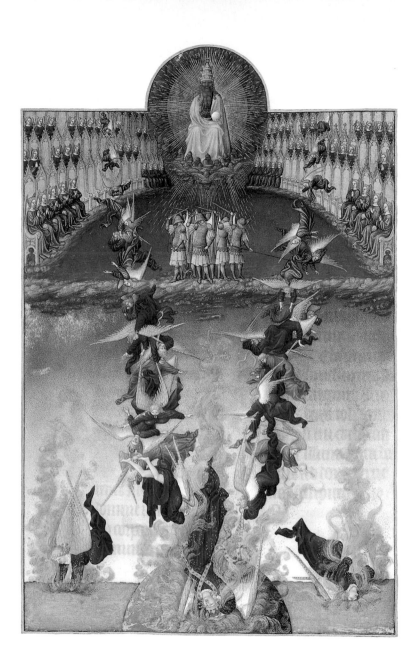

The Fall of the Rebel Angels. The sphere of the heavens with their Lord
is set against the globe of the Earth with its fallen anti-king:
a breath-taking composition, intellectually and visually daring.

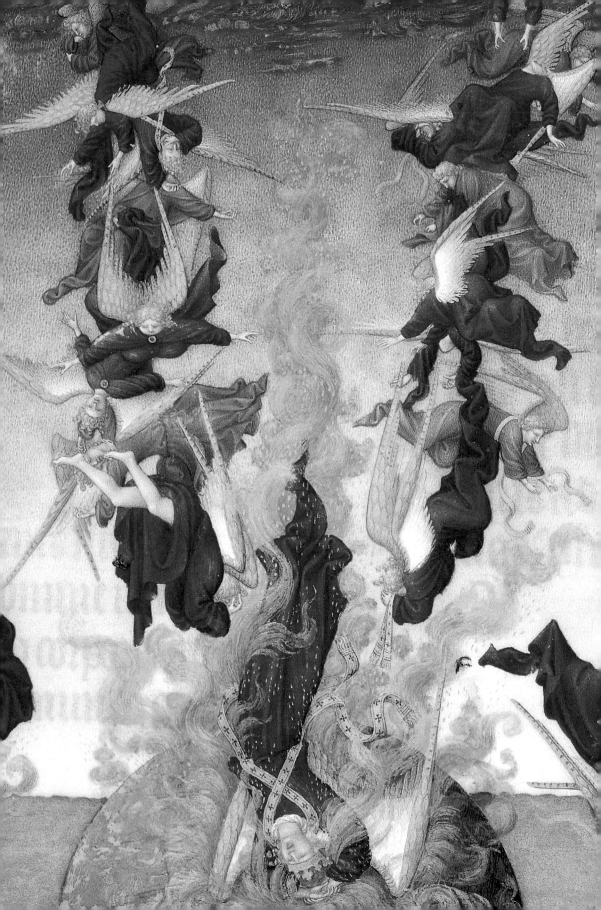

judgement of the Lord sends a third of Lucifer's followers tumbling down from Heaven for having opposed His plan to create Man in His own image.

The composition of this furious *Fall of the Rebel Angels* (p. 110) creates a dynamic sense of speed and space with its streams of figures increasing in size as they plummet down diagonally from above, turning and foreshortened by the angle of their fall. Based on the "colour chord" of blue and gold, there are subtle variations in the use of colour: as they drop from the heavens the rebel angels lose the green from their wings and the gold lights on their raiment, for in religious imagery green, as the symbol of eternal life, was at times associated with saints' clothes. *The Fall of the Rebel Angels* was in itself a most unusual subject, and while some contemporary representations depict the satanic transformation of the figures, the Limbourg brothers keep faith here with the notion of anthropomorphic beauty.

Even in *Hell*, its counterpart, the demons are positively decorative: grimacing male figures with horns and bats' wings, who seem to have stepped out of some fairly comfortable Italian inferno just as the damned seem curious rather than terrified. This is all the more surprising in view of the late medieval proliferation of rampant devil-fantasies bolstered by bestial ugliness and sexual perversions, all of which were nurtured by sorcerers and black magicians who took advantage of the strange atmosphere emanating from the mentally unstable Charles VI. *Hell* is as impressive in its composition as its counterpart: in between columnar flames, smoke, sparks and mountains, the fiery breath of the Prince of Darkness hurls the damned high into the air, while he crushes others with his hands and feet as his assistants work the bellows and roughly keep him supplied with more victims, one even riding on the back of a cleric. The whole scene is painted in dark or red-tinged gold and sulphur yellow, with very distinctive shading in greys and blues. Both of these miniatures are amongst the eight

Hell

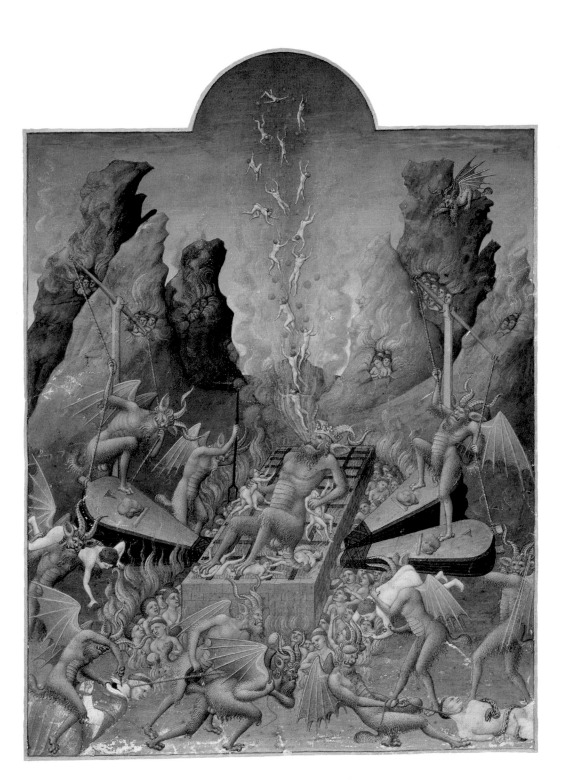

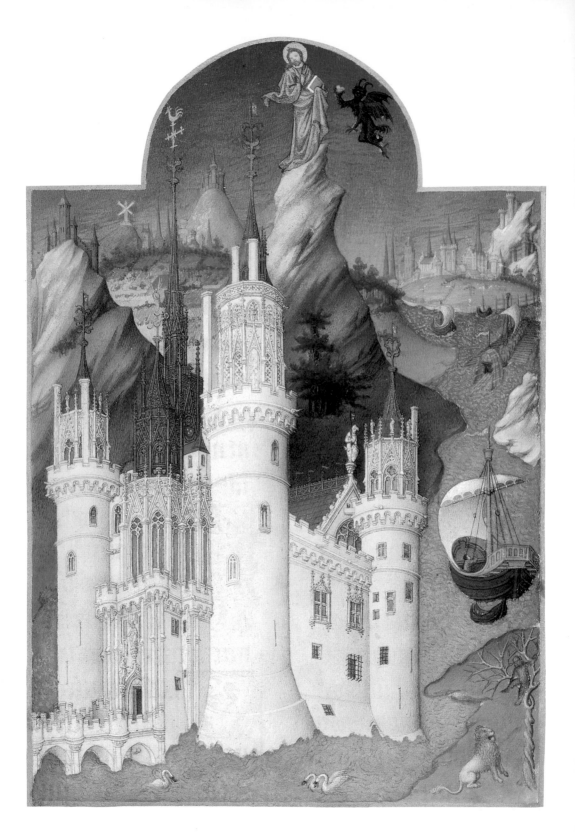

individual pages included in the manuscript as a kind of after-thought, with *The Fall of the Rebel Angels* preceding the psalms of repentance and with *Hell* following the Office of the Dead.

Satan is also the subject — or ought to be — of *The Temptation of Christ*, illustrating the text of the mass for the first Sunday in Lent, for it was after Christ had spent forty days and nights fasting in the desert that the devil came to tempt Him. At his third attempt the devil took Christ up an "exceeding high mountain" and promised him "all the kingdomes of the world and the glory of them" (Matthew IV, 1–13) if Christ would worship him. What a compliment to the Duke that the artist portrays that "glory" in the shape of the Château Méhun-sur-Yèvre near Bourges which the Duke had had so opulently re-novated! It is almost blasphemous the way the portrait of the château takes possession of the picture space, while the real subject-matter of the scene — unusual as it is — withdraws into the skies above and the devil transforms into a rather charming little dragon. The rock in the devil's hand and the chapel spire reaching up to the figure of Christ are a deft re-ference by the artist to the other two temptations: for Christ to turn stone into bread or to cast Himself down from the pinnacle of the temple.

A Baroque drawing of the château depicting it before it fell into ruin shows that the portrayal in the miniature is accurate down to the last detail of its architecture and the filigree tracery of its turrets. Other splendid ducal properties beckon alluringly in the background like a fata morgana. And all around there is a finely painted patchwork of lands and oceans — a whole world. And so that there should be no doubt as to who owned this "world," the Duke's emblems come alive: the swans dip their heads into the River Yèvre and the bear climbs the tree. Does this then also mean that the lion threatening him below represents wicked Burgundy?

The little dragon demon reappears in *The Exorcism*. The Gos-pel according to Saint Luke describes how Christ drove the de-

The Temptation of Christ

vil out of a dumb man and restored his speech. This very scene takes place at the entrance to a temple: the demon is seen rising up out of the head of the convulsed young man, who is being supported by his mother. On one side the Pharisees watch, gesticulating in alarm and denial, while on the other side a crowd of onlookers observes the scene with astonished curiosity. The many curved forms create a sense of excitement and movement: rhythmic gestures, rounded turbans and the arches of the temple are echoed by arabesques of golden foliage against the deep blue background of the sky, an "old-fashioned" technique that the Limbourg brothers had previously used in the *Belles Heures*. The astounding gradations of blue in the clothes, arches and tiles show, as Millard Meiss points out, the artists' "extraordinary French feel for this colour."[25] The view from below of the architectural sculptures on the temple itself — here and in other miniatures — is an innovation which quite clearly influenced Jan van Eyck's *Adam and Eve* on the Ghent Altarpiece.[26] Such a small step and yet a giant leap for painting!

The silky-smooth surface of *The Raising of Lazarus* is also dominated by a wonderful blue, a calming backdrop to the oranges, greens and yellows. This was a popular subject, and particularly so in France where the relics of Saint Lazarus were kept and worshipped in St Lazare in Autun. The miniaturists have chosen to depict a section of the Gospel according to Saint John that is rather difficult to illustrate: the moment when Christ shows His confidence in His own eternal existence by making the brief yet grandiose statement "Before Abraham was, I am." (John VIII, 58). This, of course, matches the words He uttered during the Raising of Lazarus: "I am the resurrection and the life." (John XI, 25).[27] As proof of this, Christ performs a miracle. The cover is removed from the coffin and with an imploring gesture He calls His dead friend to come forth from the grave. Some of the bystanders hold their noses and think that the deceased man is going to smell badly, having been buried four days before. Instead they see a naked man rise

The Exorcism

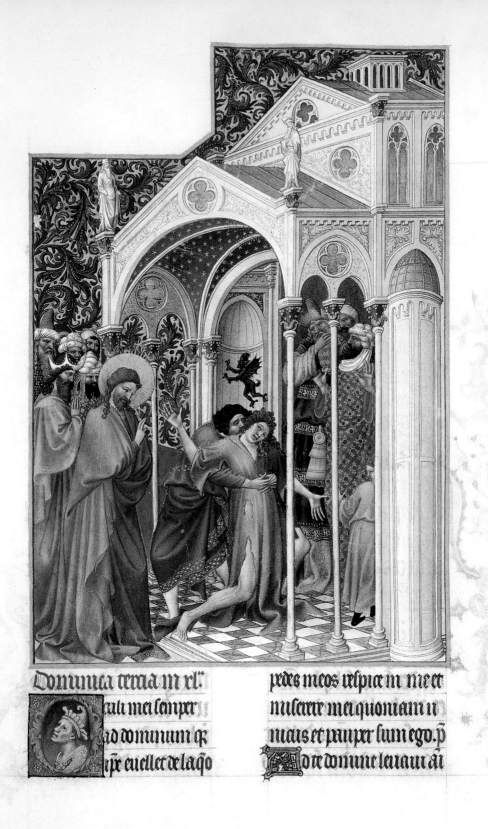

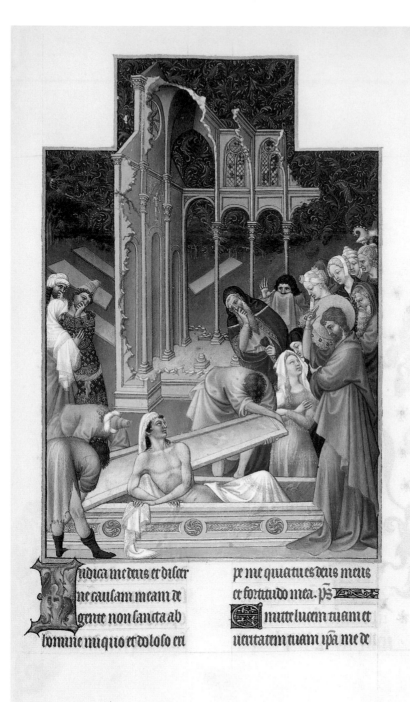

The Raising of Lazarus

Lazarus in this portrayal has been compared to a reclining
river-god: he seems so immaculate as he rises from the coffin,
framed in a lively interplay of eyes and hands.

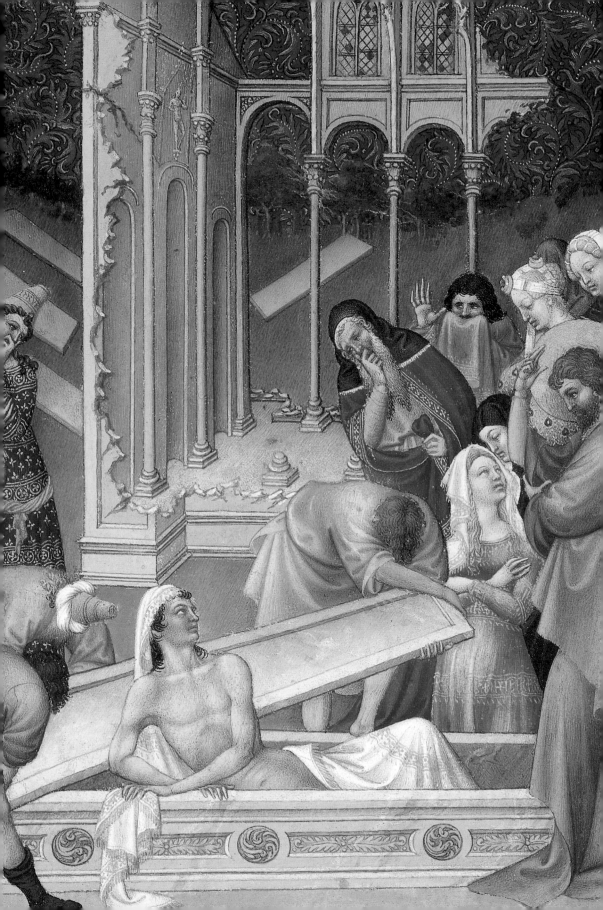

up from his coffin in the full flowering of his beauty, with clas-
sical features and in the relaxed pose of a statue from antiquity.
Watched with amazement by a pyramid of onlookers, Lazarus
gazes at Christ with the same endless faith as does his sister
Mary — making this one of the most moving and, at the same
time, most elegant representations of this miracle. As far as the
iconography of the subject is concerned, the ruined temple in
the background is an oddity: it may be a reference to Christ's
promise to rebuild a temple in three days (John II, 19) or simply
be a symbol of the decay of the ancient world. At all events, the
naked heathen idol on the left wall of the interior must remain
a mystery.

The French historian Georges Duby gives the following ex-
planation of this picture of the "other resurrection": "With
this, the Limbourg brothers gave the ageing Jean de Berry a
form of double hope combining traditional chivalric optimism
with the principles of humanism now coming from Italy. Both
chivalry and humanism anchored their hope in this world.
A picture of this sort could only flourish where civilisation as
it was known in 1400 had reached its highest point, in that
extraordinary mixture of worldly display and spirituality, of
curiosity and elegance, as found in the court in Paris before the
fateful blows struck by the war destroyed it."[28]

In one of the last miniatures, *The Mass of Saint Michael*, we see
the epitome of hope in the form of Saint Michael — one of the
Duke's favourite chivalric dragon-slayers — triumphing over
Satan. The setting for his victory is his own Mont-Saint-Mi-
chel on the coast of Normandy. In the Middle Ages this was
a famous place of pilgrimage, and with its thirteenth-century
"royal Gothic" architecture was later the seat of the Order of
the Knighthood of St. Michel. The portrait of Mont-Saint-
Michel in the *Très Riches Heures* therefore represents the apo-
theosis of France, while the Duke's coat of arms on one of the
accompanying miniatures would seem to be a clear statement
of intent by this Prince of Valois.

The Mass of Saint Michael

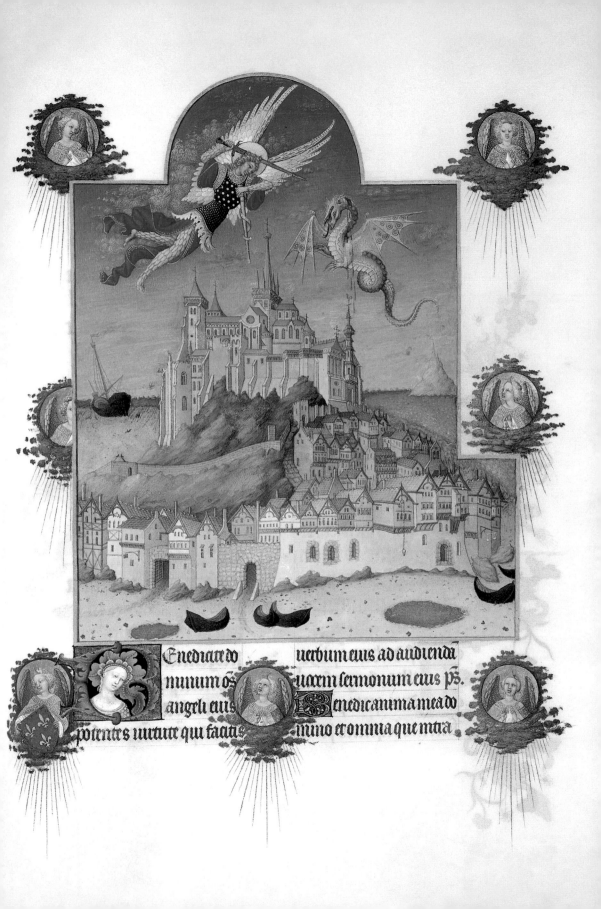

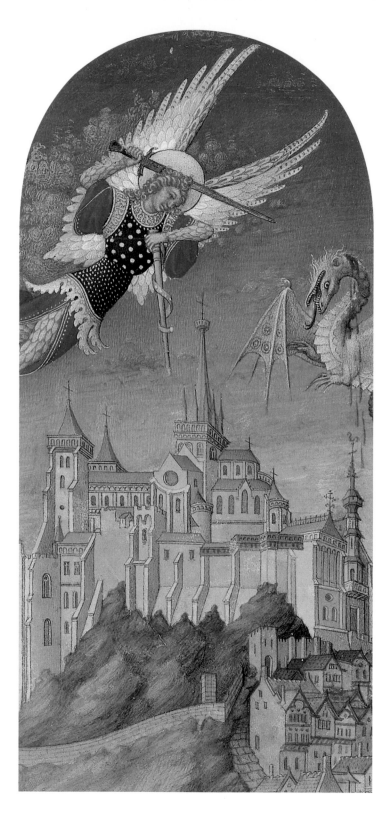

The triumph of good over
evil in the skies above a French
national shrine.

Angels also painted by the Limbourg brothers look out from their medallion windows and follow the battle between the two gold-gleaming combatants: the elegantly armoured Michael with his sword and lance — angelic wings blazing and smoking — throws himself at the dragon, who has already been struck and bends his head furiously but with uncommon grace towards the blood running from his neck. This depiction of Mont-Saint-Michel is not the first in a Book of Hours, but it is one of the most accurate; with the fortified abbey, the town below and the boats lying on the sand at the ebb-tide, it is also one of the most picturesque. The tip of the abbey spire almost touches the wings of Saint Michael: just as Heaven almost touches the Earth in this book.

Notes

1 Ferdinand Seibt: *Karl IV. Ein Kaiser in Europa* (Munich, 1978), p. 23.

2 Ibid.

3 Examples cited by Johan Huizinga: *Herbst des Mittelalters*, German by Kurt Köster, 11th edn (Stuttgart, 1975), pp. 4, 23, 25, 28, 39, 250; Barbara Tuchman: *Der ferne Spiegel*, German by Ulrich Leschak and Malte Friedrich (Düsseldorf, 1980), p. 75.

4 William Shakespeare: *King Richard the Third*, IV, 4.

5 See Huizinga (note 3), p. 88.

6 Georges Duby: *Die Zeit der Kathedralen*, German by Grete Osterwald, 3rd edn (Frankfurt am Main, 1980), p. 450.

7 Ferdinand Seibt: *Glanz und Elend des Mittelalters* (Berlin, 1987), p. 233.

8 See Tuchman (note 3), p. 387.

9 For example, until recently it had been thought that the brothers Herman and Jean (in fact, these were two other nephews of Jean Malouel) had been apprenticed as goldsmiths in Paris and, having been arrested in 1399 in Brussels on their return for political reasons, had been bought out of prison by the Duc de Bourgogne: Raymond Cazelles and Johannes Rathofer, *Das Stundenbuch des Duc de Berry: Les Très Riches Heures* (Lucerne, 1988), p. 219.

10 Millard Meiss: *French Painting in the Time of Jean de Berry*, 3 vols. (London and New York, 1967, 1968, 1974); vol. 3, *The Limbourgs and their Contemporaries* (1974), p. 75.

11 See Cazelles and Rathofer (note 9), pp. 226 ff., pp. 234–40.

12 Ibid., pp. 222 f.

13 Harry Bober, "The Zodiacal Miniature of the *Très Riches Heures* of the Duke of Berry: Its Sources and Meaning," *Journal of the Warburg and Courtauld Institutes*, vol. 11 (1948), pp. 1–34.

14 Sebastian Klusak, "Die Seelen der Planeten," *Frankfurter Allgemeine Zeitung*, December 21, 1996, no. 298) supplement.

15 Martin Warnke, *Politische Landschaft. Zur Kunstgeschichte der Natur* (Munich, 1992), p. 13.

16 See Meiss (note 10), p. 196.

17 Matthias Eberle, *Individuum und Landschaft. Zur Entstehung und Entwicklung der Landschaftsmalerei* (Gießen, 1980), pp. 146 f.

18 Ibid., p. 149.

19 See Huizinga (note 3), p. 229.

20 See Meiss (note 10), p. 150.

21 Michael Bath, "Imperial renovatio Symbolisms in the *Très Riches Heures*," *Simiolus*, 17 (1987), pp. 5–22.

22 See Cazelles and Rathofer (note 9), p. 240.

23 Jean Lorgnon und Raymond Cazelles, *Les Très Riches Heures du Jean Duc de Berry, Musée Condé, Chantilly* (London, 1969), commentary to pl. 107.

24 See Cazelles and Rathofer (note 9), p. 160.

25 Millard Meiss and Elizabeth H. Beatson, *Die Belles Heures des Jean Duc de Berry in The Cloisters, New York* (Munich, 1974), p. 20.

26 Otto Pächt, *Van Eyck* (München, 1989), p. 29.

27 See Cazelles and Rathofer (note 9), p. 178.

28 See Duby (note 6), p. 549.

Selected Bibliography

Baxandall, Michael. *Shadows and Enlightenment*. New Haven, 1995.

Bober, Harry. "The Zodiacal Miniature of the *Très Riches Heures* of the Duke of Berry: Its Sources and Meaning," *Journal of the Warburg and Courtauld Institutes*, vol. 11 (1948), pp. 1–34.

Cazelles, Raymond, and Johannes Rathofer. *Das Stundenbuch des Duc de Berry: Les Très Riches Heures*. Lucerne, 1988

Duby, Georges. *Die Zeit der Kathedralen*, German by Grete Osterwald, 3rd edn. Frankfurt am Main, 1980.

Eberle, Matthias. *Individuum und Landschaft. Zur Entstehung und Entwicklung der Landschaftsmalerei*. Gießen, 1980.

Gundel, H. G. *Zodiakos: Tierkreisbilder im Altertum*. Mainz, 1992.

Hansen, Wilhelm. *Kalenderminiaturen der Stundenbücher*. Munich, 1984.

Huizinga, Johan. *Herbst des Mittelalters: Studien über Lebens- und Geistesformen des 14. und 15. Jahrhunderts in Frankreich und in den Niederlanden*, ed. and trans. into German by Kurt Köster, 11th edn. Stuttgart, 1975.

Keller, Horst. *Italien und die Welt der höfischen Gotik*. Wiesbaden, 1967.

Lognon, Jean, and Raymond Cazelles. *Les Très Riches Heures du Jean Duc de Berry, Museé Condé, Chantilly*. London, 1969.

Meiss, Millard. *French Painting in the Time of Jean de Berry*: vol. 1, *The Late XIVth Century and the Patronage of the Duke*. (London and New York, 1967); vol. 2 *The Boucicault Master* (1968); vol. 3, *The Limbourgs and their Contemporaries* (1974).

Meiss, Millard, and Elizabeth H. Beatson. *Die Belles Heures des Jean Duc de Berry in The Cloisters, New York*, German by Doris Schmidt, Monika Rosenauer, Lillian Schacherl and Maria Schmidt-Dengler. Munich, 1974.

Schiller, Gertrud. *Ikonographie der christlichen Kunst*, vols. 1–4,2. Gütersloh, 1969–81.

Seibt, Ferdinand. *Karl IV. Ein Kaiser in Europa*. Munich, 1978.

Seibt, Ferdinand. *Glanz und Elend des Mittelalters. Eine endliche Geschichte*. Berlin, 1987.

Thomas, Marcel. *Buchmalerei aus der Zeit des Jean de Berry*, German by Helmut Schneider and Brigitte Sauerländer. Munich, 1979.

Tuchman, Barbara. *Der ferne Spiegel*, German by Ulrich Leschak and Malte Friedrich. Düsseldorf, 1980.

List of Illustrations